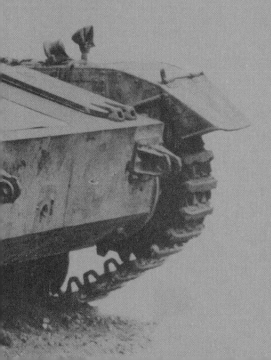

LEGENDS OF WARFARE

GROUND

Panzerkampfwagen IV

The Backbone of Germany's WWII Tank Forces

DAVID DOYLE

Schiffer Publishing Ltd

4880 Lower Valley Road • Atglen, PA 19310

Designed by Justin Watkinson
Type set in Impact/Minion Pro/Univers LT Std

ISBN: 978-0-7643-5359-8
Printed in China

Published by Schiffer Publishing, Ltd.
4880 Lower Valley Road
Atglen, PA 19310
Phone: (610) 593-1777; Fax: (610) 593-2002
E-mail: Info@schifferbooks.com
www.schifferbooks.com

For our complete selection of fine books on this and related subjects, please visit our website at www.schifferbooks.com. You may also write for a free catalog.

This book may be purchased from the publisher.
Please try your bookstore first.

We are always looking for people to write books on new and related subjects. If you have an idea for a book, please contact us at proposals@schifferbooks.com.

Schiffer Publishing's titles are available at special discounts for bulk purchases for sales promotions or premiums. Special editions, including personalized covers, corporate imprints, and excerpts can be created in large quantities for special needs. For more information, contact the publisher.

Acknowledgments

Compiling a book of this nature is a task that requires a number of people, sometimes working together, sometimes independently, for a number of years, often spanning decades. Much of this book is comprised of archival images, with the adjacent photo credits providing a modest background to those images. However, a greater explanation is warranted. The Patton Museum, formerly at Fort Knox, Kentucky, held two large collections that were used in preparing this book. One of these was assembled by Robert J. Icks over a period of decades. Col. Icks, a career ordnance officer, was also one of the earliest authors of books on military vehicles. The second collection from the Patton Museum that was utilized for this project is the collection of Richard Hunnicutt. Richard, a long-time friend of Walter Spielberger, had copies of much of Walter's collection of materials—so much so that when Walter's home burned, destroying many records, Richard was able to provide copies that were the basis for rebuilding the collection. Richard connected me to Walter, and both were gracious in assisting me with assembling my own collection.

Perhaps even more convoluted is the story of many of the images in this volume that were sourced from the US National Archives and Records Administration. This agency is the official custodian of US military-created photographs of the World War II era. However, beyond that the Archives also held the German wartime photograph collection now held by the Bundesarchiv in Germany. As World War II wound down US troops captured what is believed to be about one-half of the images taken by *kriegsberichters*—the German equivalent of US Signal Corps photographers. These captured materials were housed at the US National Archives from 1947 until 1968, at which time they were shipped to the Federal Republic of Germany—but not until after copies had been made.

Beyond the invaluable help provided by the staffs of the National Archives and the Patton Museum, I am indebted to Tom Kailbourn, Scott Taylor, and Massimo Foti. Their generous and skillful assistance adds immensely to the quality of this volume. I am especially blessed to have the faithful and tireless help of my wonderful wife Denise, who has scanned thousands of photos and documents for this and numerous other books. Beyond that, she has been an ongoing source of support and inspiration.

Contents

Introduction

The Panzerkampfwagen IV, commonly referred to as the Panzer IV, was a key part of Nazi Germany's armored strategy during World War II. With its relatively heavy—at least at the outset of the war—75 mm main gun the Panzer IV was intended to comprise heavy tank companies of tank battalions. Each battalion was to include one heavy tank company and three medium tank companies utilizing the Panzer III. The Panzer IVs were to be used against heavy fortifications and the like, while the Panzer IIIs dealt with enemy tanks and infantry.

Ultimately, like many other weapon systems, the role of the Panzer IV evolved, and in time a longer, higher velocity 75 mm gun began to be used, and the Panzer IV became the core vehicle of German armor. It would become the only German tank to remain in production throughout the duration of World War II, as well as the most produced tank in the Nazi arsenal. Germany even exported the Panzer IV to her allies, with Bulgaria receiving ninety-one, Italy twelve, Romania 126, Finland fifteen, Spain twenty, Turkey fifteen, and Hungary eighty-four.

Development of a tank of this type began well before World War II. In fact, the development program that led to the Panzer IV even predated Hitler's rise to power.

On June 28, 1919, Germany, under threat of invasion and potential annihilation, reluctantly signed the Treaty of Versailles, bringing to an end the World War begun five years earlier. Germany, arguably the primary aggressor in that conflict, was compelled to sign a treaty which forever banned the nation from the manufacture or purchase of armored cars or tanks.

Treaty provisions notwithstanding, by 1926, Germany was already clandestinely working on tank designs. The following year contracts were placed for production of prototype tanks, code named *grosstracktor*, or large tractor. Ultimately, six examples were produced, two each from Krupp, Daimler-Benz and Rheinmetall, with the vehicles being completed in 1929. These vehicles were then shipped to a secret German tank training facility, the Kama Tank School, which was located at Kazan, Soviet Union. This was a result of a German/Soviet conspiracy to hide the German tank program from the remaining Allied powers. It is worthwhile to note that the Krupp design was the work of Senior Engineer Erich Woelfert. Woelfert would remain part of the Panzer IV program to the very end.

From these lessons, by 1932, Germany had begun considering production of a new medium tank. Initially referred to as the *mittlere tracktor*, or medium tractor, that code name was replaced with *Neubaufahrzeug*, or newbuilt vehicle, by October 1933. At about the same time, the secret Kama tank school in Kazan was closed, owing to political gains by Germany at the Geneva Conference and the growing friction between the Communist Soviet Union and the newly emplaced Nazi regime.

Initially, two mild steel prototypes of the newbuilt vehicle were contracted, one to have both turret and chassis designed by Rheinmetall, and the second to have a Krupp-designed turret on a Rheinmetall chassis. The main gun was to be a 75 mm KwK 37 L/24, or 75 mm *Kampfwagenkanone*, or tank gun, with a barrel 24 calibers (75 mm) long. Secondary armament was a 37 mm KwK 36 L/45.

The mild steel prototypes of the newbuilt vehicle, completed in 1934 and early 1935, were followed by three more examples made with armor, and all featuring the Krupp turret, completed in 1935–36. In April 1940, the three armored examples were deployed during the German invasion of Norway.

The next stage in German medium tank design was the escort vehicle, or *begleitwagen*, often abbreviated BW. Preliminary designs for the new tank were requested from Rheinmetall and Krupp in 1934. On February 26, 1935, a contract was awarded to Rheinmetall to construct a wooden mockup as well as a mild steel prototype of their chassis design. A similar contract was issued to Krupp as well.

While the tanks discussed previously in this book were powered by aircraft engines driving through rear-mounted drive sprockets, the BW was required to be driven through front-mounted drive sprockets, and a specially designed tank engine was the powerplant of choice.

Designed and produced by the prestigious firm of Maybach, the 10-liter liquid-cooled V-12 gasoline engine, model number HL 100 TR, developed 300 horsepower at 3,000 rpm.

The Rheinmetall prototype used suspension components originally designed for the *Neubaufahrzeug*, while the two Krupp prototypes each had different types of suspensions. The Krupp BW I utilized eight pairs of 420 mm diameter road wheels per side, mounted two pair per bogie via leaf springs. The BW II was equipped with six pairs of larger road wheels with torsion bar suspension on each side.

The BW I prototype was completed and operational on April 30, 1936. The BW II was not initially completed with a turret, but rather was tested as chassis only. It would be mid-1938 before a turret was installed on this, and that was short-lived, as by 1939 the chassis was being used as a test article for bridge layers. Test results of the torsion bar suspension were not favorable, and early on it was decided that production BW vehicles would utilize the leaf spring suspension of the BW I prototype.

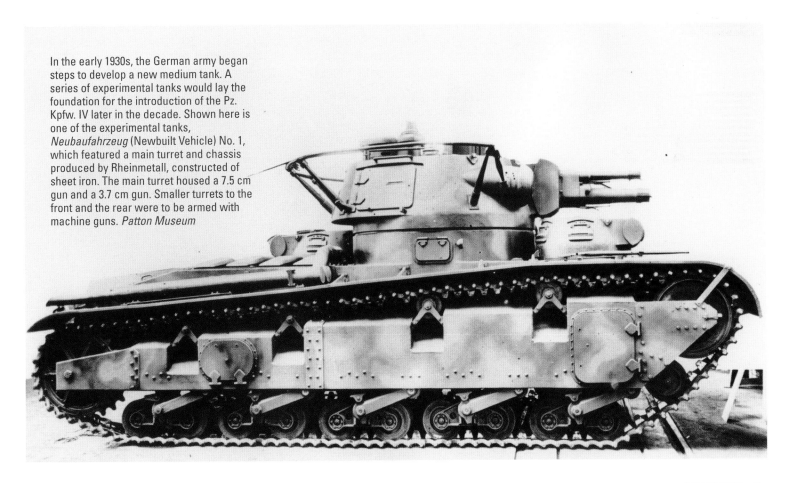

In the early 1930s, the German army began steps to develop a new medium tank. A series of experimental tanks would lay the foundation for the introduction of the Pz. Kpfw. IV later in the decade. Shown here is one of the experimental tanks, *Neubaufahrzeug* (Newbuilt Vehicle) No. 1, which featured a main turret and chassis produced by Rheinmetall, constructed of sheet iron. The main turret housed a 7.5 cm gun and a 3.7 cm gun. Smaller turrets to the front and the rear were to be armed with machine guns. *Patton Museum*

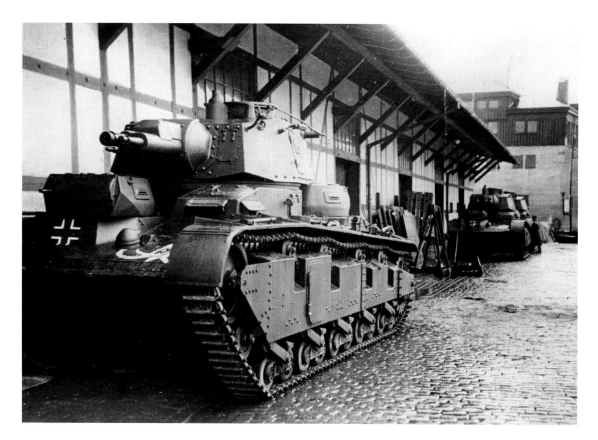

After two initial sheet-iron vehicles, three additional examples of the *Neubaufahrzeug* were produced. These had chassis built by Rheinmetall and main turrets by Krupp. Rather than the over-under gun arrangement of the first *Neubaufahrzeug*, the third through fifth examples placed the 3.7 cm gun to the left side of the 7.5 cm gun. Also the machine gun turrets were of a different design than those on the No. 1 vehicle, with faceted frontal armor. *Bundesarchiv 101I-759-0140N-21*

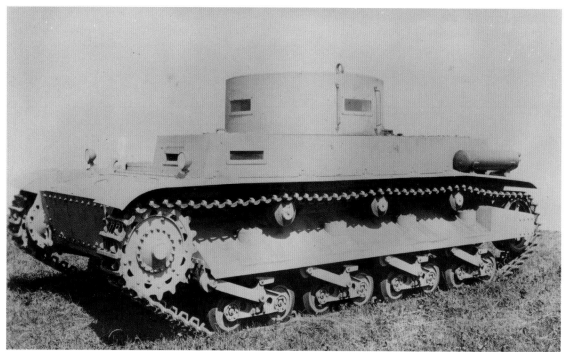

The next stage in the development of the German medium tank was the *Begleitwagen* (BW) test vehicle, constructed by Rheinmetall. This photo shows the BW in its original configuration. The vehicle was powered by the Maybach Type HL 100 TR engine. There were eight road wheels on four bogies per side, and the tracks were adapted from those of the *Neubaufahrzeug*. The BW was to be armed with a 7.5 cm gun and two machine guns, but the vehicle seen here had a rounded enclosure with small windows instead of a turret. *Patton Museum*

As the design was refined, the fender, exhaust, and idler area were revised as seen here. The rounded enclosure above the superstructure had a flat door on the rear, shown in the open position here. The sprockets were to the front and the idlers to the rear. Above the bogie assemblies was a sloping plate to shed mud. A muffler was attached to each side of a louvered air vent on the rear of the hull. *Patton Museum*

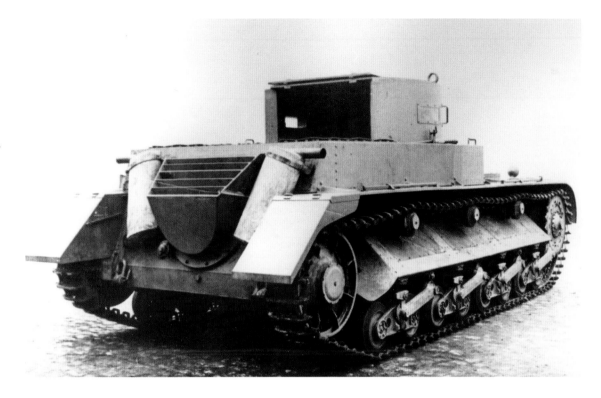

In addition to the BW test vehicle Rheinmetall produced, Krupp built two BWs, designated BW I and BW II. The BW I, shown here, had a turret, hull, and running gear quite similar to those of the forthcoming Pz.Kpfw. IV Ausf. A. As seen in this view of the BW I without the bogies installed, the front of the superstructure had the same stepped design as the Pz. Kpfw. IV Ausf. A. The 7.5 cm gun was equipped with an antenna deflector fashioned from heavy wire. The folding antenna on the right side of the superstructure, shown here lowered into its holder above the right fender, would carry over to the Pz.Kpfw. IV. Krupp's BW II was quite different in design from the BW I. *Patton Museum*

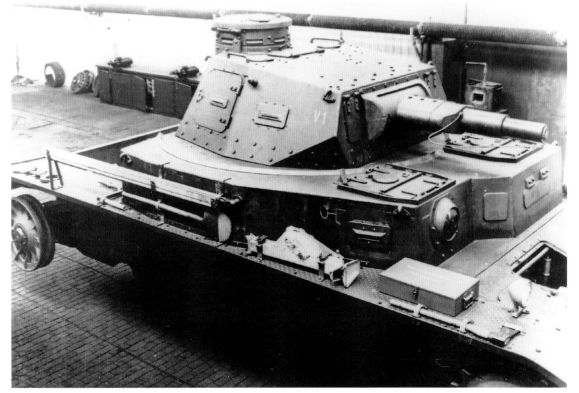

CHAPTER 1
Panzer IV Ausf. A

Ausf. A 1.series B.W. (Begleitwagen)	
Make	Krupp-Grusonwerk
Chassis (Fgst) number	80101-80135
Quantity	35
Dimensions	
Length	19′ 5.07″
Width	9′ 3.42″
Height	8′ 9.51″
Wheelbase	7′ 10.9″
Track contact	11′ 6.58″
Weight	39,690 pounds
Automotive	
Engine	Maybach HL108TR
Configuration	V-12, water-cooled
Displacement	10.8 liters
Power output	230 hp @ 2,600 rpm
Fuel capacity	124 gallons
Transmission	ZF S.S.G.75
Speeds	5 + reverse
Steering	differential
Track	Kgs 6110/380/120
Links per side	99
Performance	
Crew	5
Max speed	20 mph
Cruising speed	12.5 mph
Cross-country	6 mph
Range, on-road	130 miles
Range, cross-country	80 miles
Fording depth	31.5″
Trench crossing	7.5′
Armament	
Main gun	7.5 cm Kw.K. 37 L/24
Range	2,000 meters
Coaxial	7.92 mm MG 34
Elevation	-10 to +20 degrees
Ball mount	7.92 mm MG 34
Ammo, 7.5 cm	122 rounds
Ammo, 7.92 mm	3,000 rounds

By late 1936, the BW I chassis had racked up over 1,250 miles in tests, and the list of desired improvements was relatively short. Also, earlier in the year a general army bulletin was issued standardizing the nomenclature on armored vehicles. Thus, in December of that year a production contract for thirty-five 1.Serie/BWs (first series escort vehicles) was issued to Krupp-Grusonwerk. These vehicles, designated Panzer IV Ausführung (type) A, appeared nearly identical to the BW I, yet in fact almost every component was newly engineered. The powerplant chosen was a V-12 Maybach gasoline engine, the HL 108 TR, driving through a Zahnradfabrick SFG 75 five-speed synchronized transmission. The vehicles were fabricated from homogenous, nickel-free PP694 armor ranging from 5 to 14.5 mm thickness. This provided protection from rounds up to 7.92 mm armor piercing.

The first two tanks of this series were accepted by the German army on November 30, 1937. These two tanks included stowage for 140 rounds of main gun ammunition, the highest stowage capacity for any of the Panzer IV series tanks. In order to facilitate ease of reloading the bow machine gun, the ammo stowage of subsequent Ausf. A tanks was reconfigured, resulting in main gun road stowage capacity dropping to 122 rounds—the second highest of any Panzer IV. Production of the Ausf. A continued until June 1938. While most of these tanks could be distinguished by set-back armor incorporating a machine gun ball mount in front of the radio operator's compartment, that was not the case for the final five examples. Because Harkort, Essen had failed to deliver the final five first series hulls on time, Krupp chose to assemble the final five Ausf. A tanks with upper hulls originally produced for the Ausf. B, which were already on hand at the plant. These hulls lacked the ball mount machine gun as well as the setback of the radio operator's compartment.

Friedrich Krupp AG Grusonwerk produced thirty-five examples of the first model of the Pz.Kpfw. IV, the *Ausführung A* (Model A, hereafter abbreviated as Ausf. A). The front of the superstructure was very similar to that of the BW I test vehicle, except the driver's visor had a beveled profile. The two small holes above the hinges for that visor were apertures for the driver's binocular periscope. To the left of the visor (towards the vehicle's right) are a square pistol port and a ball mount for an MG 34. The turret is traversed to the rear, showing details of the cupola and the two square pistol ports to its sides. Above those ports are lifting hooks. *Patton Museum*

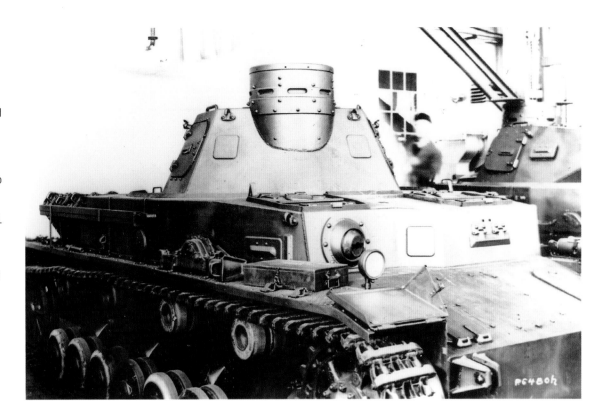

A Pz.Kpfw. IV Ausf. A is seen from the rear with the turret oriented to the front. The muffler was a large, cylindrical assembly that extended nearly the entire width of the hull. The exhaust outlet was on top of the left side of the muffler. Above the fender on the right fender is the antenna holder. To the side of the engine compartment is the engine cooling-air intake, with three horizontal louvers, and two vertical dividers. *Patton Museum*

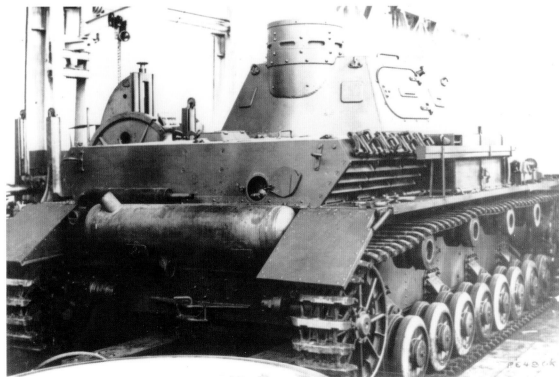

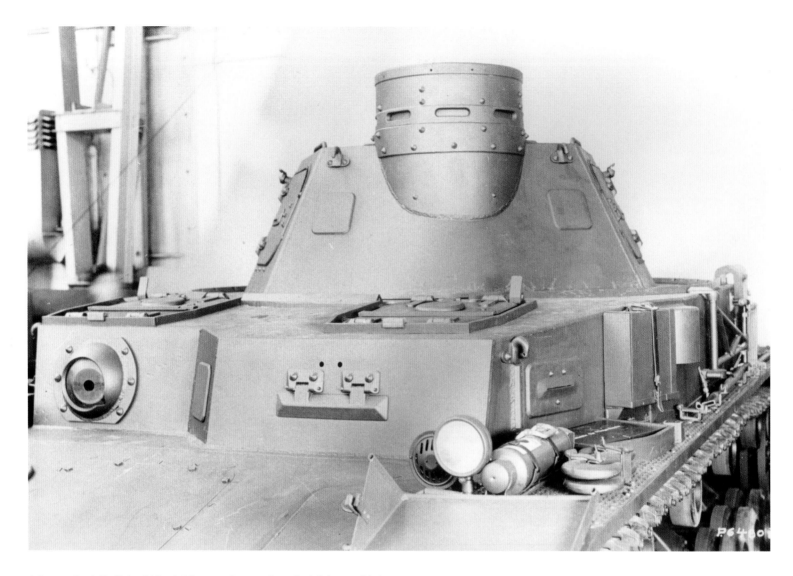

A factory-fresh Pz.Kpfw. IV Ausf. A is seen close-up from the left front, with the turret traversed to the rear, allowing a clear view of the cupola and its curved base and a crisp view of the ball mount for the bow MG 34, the pistol port, and the driver's front visor. On the left fender are the folded mudguard, headlight, horn, fire extinguisher, and two stacked C-hooks for attaching tow cables to the vehicle. To the rear of the driver's side visor is a wooden jack block. Flanking the cupola on the rear of the turret are two pistol ports. Spare tracks are stored above the air intake. *Patton Museum*

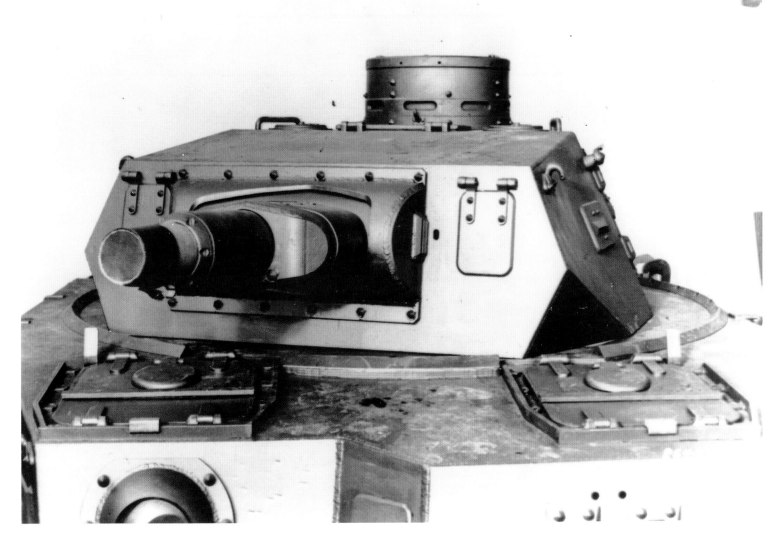

The Pz.Kpfw. IV Ausf. A was armed with the 7.5 cm KwK L/24 gun and a coaxial 7.92 mm MG 34. Protecting the area around the 7.5 cm gun was an internal/external mantlet, wherein an internal mantlet attached to the gun mount moved in elevation or depression within a fixed external mantlet screwed to the turret face. A vision port with two top hinges was on each side of the front of the turret. The driver's and radio operator's hatch covers were two-panel affairs with hinges to the front and to the rear of the hatches. A round signal port was on the rear panel of each hatch cover. *Patton Museum*

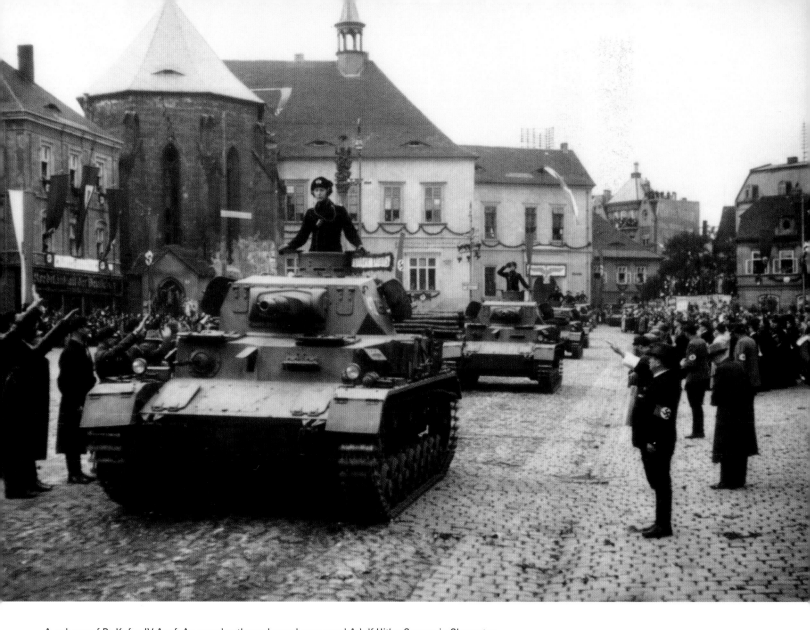

A column of Pz.Kpfw. IV Ausf. As parades through newly renamed Adolf Hitler Square in Chomutov (Komotau in German), Sudetenland, during the German seizure of that Czech region on October 9, 1938. The driver's visor and the other visors on the tank were of the same type used on the Pz.Kpfw. II Ausf. A, while the cupola also was the one used on the Pz.Kpfw. III Ausf. B and C.
National Archives and Records Administration

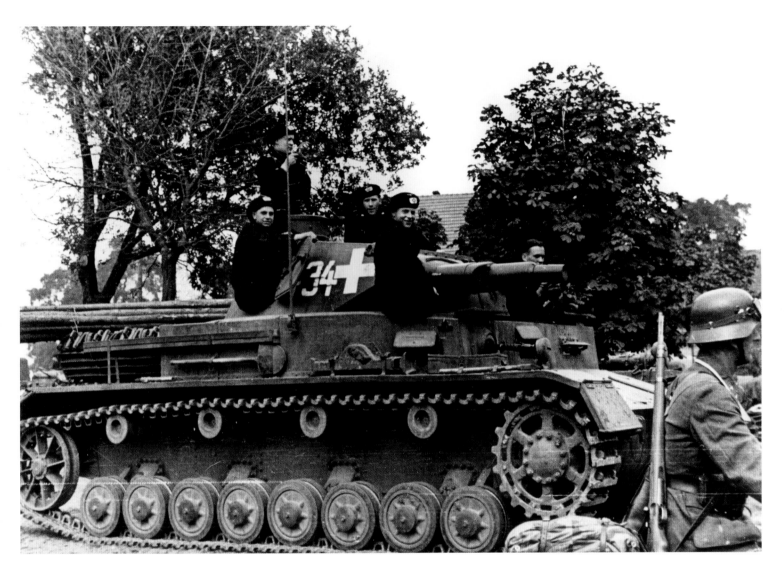

A recurring feature in the Pz.Kpfw. IV from the Ausf. A to the end of production was the use of side doors in the turret. One of the crewmen of this vehicle is seated in the right side hatch of the turret. To help eject fumes when the guns in the turret were firing, the crewmen cracked open the side hatches as well as a ventilation flap to the front of the cupola. Vehicle number 434 is painted in white on the turret of this 4. Kompanie, 1. Panzer Regiment, 1. Panzer Division vehicle in Poland; the side door hides most of the first 4. Above the shovel on the side of the sponson is a swiveling radio antenna and a protective holder for the antenna when lowered. A jack is stored on the fender. *Patton Museum*

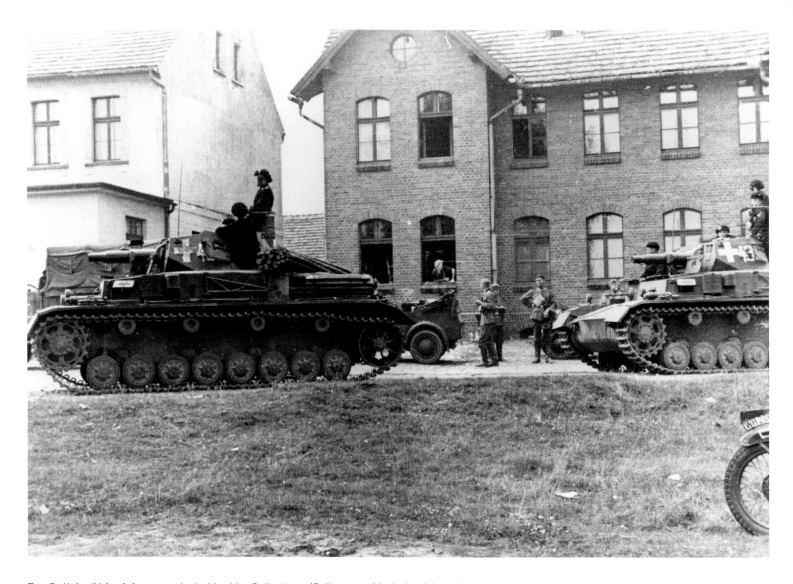

Two Pz.Kpfw. IV Ausf. As are marked with white *Balkenkreuz* (Balkan cross) insignia of the style used in the 1939 invasion of Poland. The vehicle to the right has a bright, white cross, while the one to the left has a cross and a vehicle number that have been smeared with mud or other material to reduce their visibility. A bundle of sticks is on the engine deck of the Pz.Kpfw. IV Ausf. A to the left; these were used for crossing ditches. The triangular structure on the side of the vehicle below the turret is a swiveling mount for an antiaircraft machine gun. *Patton Museum*

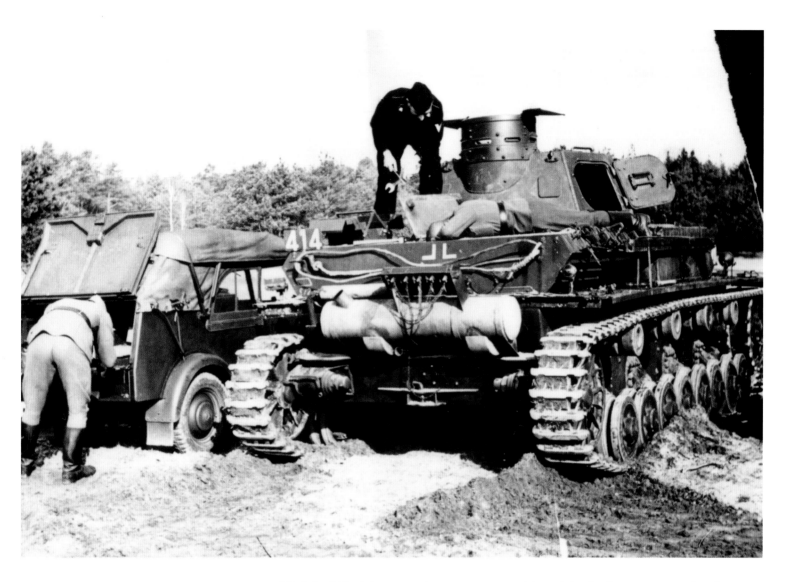

A Pz.Kpfw. IV Ausf. A crewman has a crescent wrench in each hand as he prepares to make adjustments to the engine. The number 414 is on a placard above the left rear of the hull. The structure mounted on the top of the muffler on the upper right rear of the hull is a *Nebelkerzenabwurfvorrichtung*, or smoke-grenade discharger rack, a modification introduced to the Pz.Kpfw. IV Ausf. A in August 1938.
National Archives and Records Administration

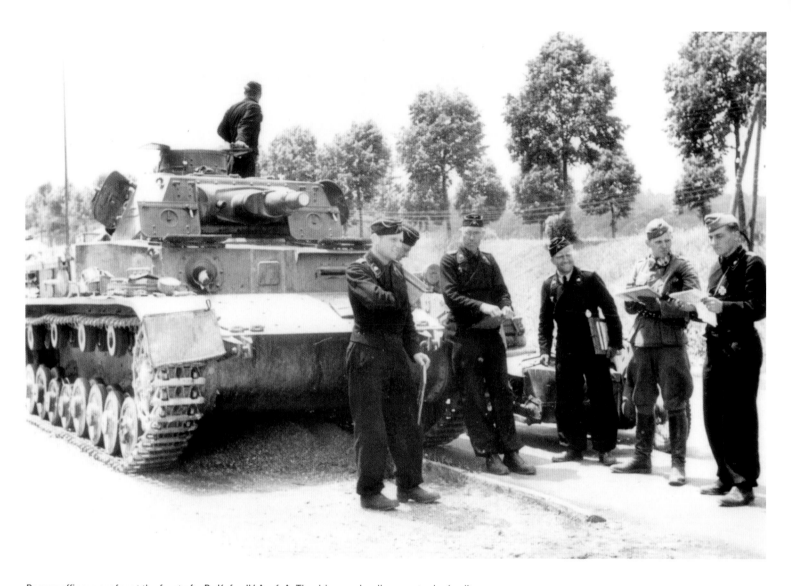

Panzer officers confer at the front of a Pz.Kpfw. IV Ausf. A. The driver and radio operator had split hatches, seen here in the open position. The locking mechanisms and signal ports are visible on the rear hatches. The square plate between the driver's visor and the bow machine gun (an MG 34) was a pistol port. Above the driver's visor is a modification: a rain deflector for the visor. A dust cover is fitted over the radio operator's machine gun. The right headlight is bent back.
National Archives and Records Administration

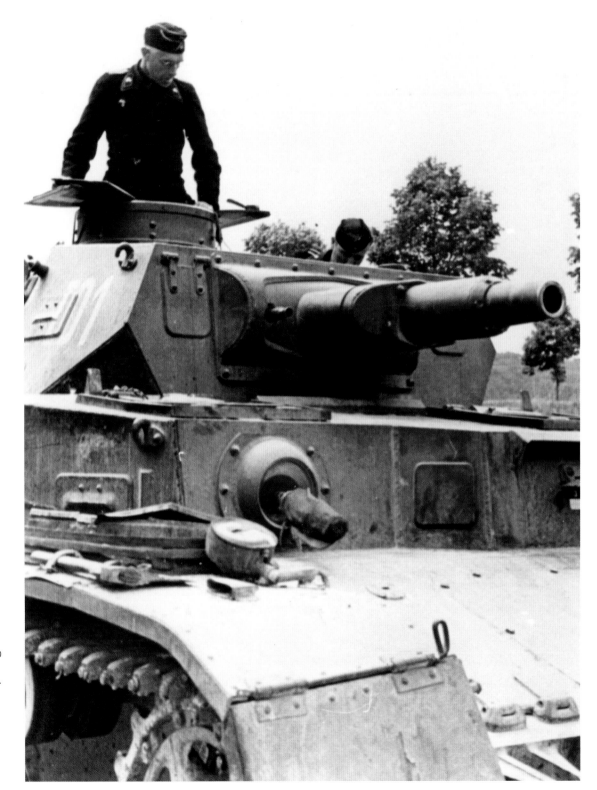

The tactical number I01 is painted in white on the side of the turret of this Pz.Kpfw. IV Ausf. A, signifying it is the tank assigned to the commander of the 1st Battalion of a panzer unit. The muzzle of the MG 34 coaxial machine gun next to the 7.5 cm gun was entirely exposed; starting with the Pz.Kpfw. IV Ausf. C, an armored sleeve would be installed over the machine gun muzzle. *National Archives and Records Administration*

An instructor in the driver's hatch of a Pz.Kpfw. IV Ausf. A holds a crescent wrench at the ready for a trainee who is adjusting the left brake assembly. On the frontal plate of the driver's compartment, partially hidden by the wrench, is the rhomboid symbol of a panzer unit. The stepped design of the front of the driver's and radio operator's compartments is displayed, and details of the left mudguard with its hinged front section are shown to the lower right. The vertical object to the front of the driver's side visor is a splashguard. The two small holes above the driver's visor are apertures for the driver's KFF binocular periscope, which enabled him to see forward when his visor was closed. *National Archives and Records Administration*

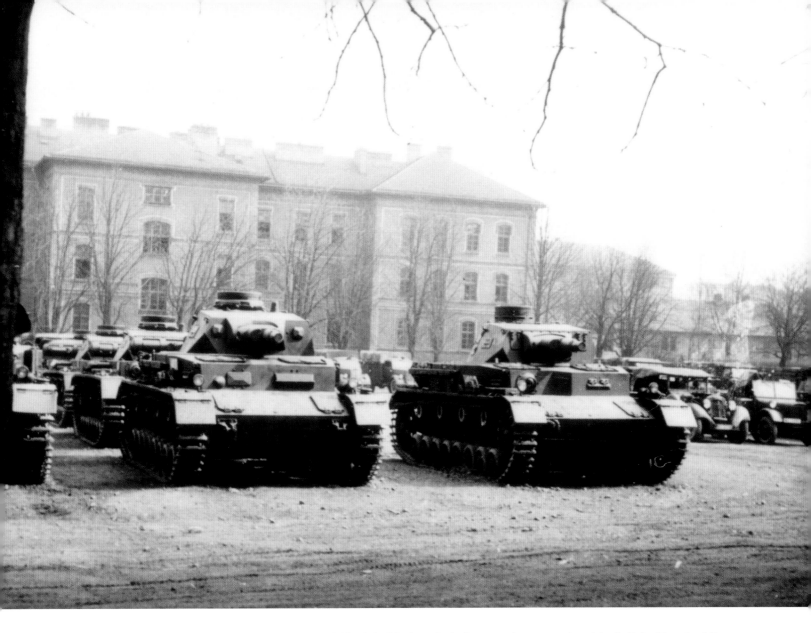

A Pz.Kpfw. IV Ausf. A, right, is parked adjacent to the next version of the Pz.Kpfw. IV, an Ausf. B, at a tank-repair workshop of the 3rd Panzer Regiment at Brno, Czechoslovakia, on March 22, 1939. The differences in the cupolas, the turret fronts (with reference to the varying observation ports), and the frontal armor of the driver's and radio operator's compartments are visible. The Ausf. B had a straight frontal plate, with the bow machine gun mount replaced by a vision port for the radio operator, with a pistol port to its immediate right. *National Archives and Records Administration*

Panzer IV Ausf. B

Ausf. B 2.series B.W. (Begleitwagen)	
Make	Krupp Grusonwerk
Chassis (Fgst) number	80201-80242
Quantity	42
Dimensions	
Length	19' 5.07"
Width	9' 3.42"
Height	8' 9.51"
Wheelbase	7' 10.9"
Track contact	11' 6.58"
Weight	40,793 pounds
Automotive	
Engine	Maybach HL120TR
Configuration	V-12, water-cooled
Displacement	11.9 liters
Power output	265 hp @ 2600 rpm
Fuel capacity	124 gallons
Transmission	ZF S.S.G.76
Speeds	6 + reverse
Steering	differential
Track	Kgs 6110/380/120
Links per side	99
Performance	
Crew	5
Max speed	26 mph
Cruising speed	15.5 mph
Cross-country	12.5 mph
Range, on-road	130 miles
Range, cross-country	80 miles
Fording depth	31.5"
Trench crossing	7.5'
Armament	
Main gun	7.5 cm Kw.K. 37 L/24
Range	2,000 meters
Coaxial	7.92 mm MG 34
Elevation	-10 to +20 degrees
Ammo, 7.5 cm	80 rounds
Ammo, 7.92 mm	2,500 rounds

Even before the first of the Ausf. A tanks had been accepted, a contract had been issued for production of forty-two follow-on tanks, the Series 2, Ausf. B. Again, Krupp Grusonwerk was the contractor for the vehicles, which were notably heavier, owing to increased armor that could now protect the front plates from 2 cm rounds, up from 7.92 mm previously. To handle the increased weight, a larger Maybach-designed HL 120 TR gasoline engine was installed, providing 285 horsepower. This engine was coupled to a SSG76 6-speed transmission, whereas the Ausf. A used a five-speed unit.

As a further effort to counter the increased weight of the thicker armor, main gun ammo stowage was decreased to eighty rounds, and more noticeably, the superstructure width was reduced as well. Previously, the superstructure was nearly as broad as that of the vehicle track width, but with the Ausf. B the superstructure extended only about half way across the tracks.

Also readily apparent was the single-plane front armor plate of the superstructure lacking a ball mount, which superseded the Ausf. A's front plate with setback at the radio operator's position. The turret of the Ausf. B utilized the same type of commander's cupola as that found on the Panzer III Ausf. C.

Production of the Ausf. B began in May 1938, and continued through October of that year.

Despite the intention that the Ausf. B be configured as described above, there was some variation. As noted earlier, Ausf. B hulls were used on the final five Ausf. A tanks because of delays in delivery of the proper Ausf. A hulls. When those hulls did arrive, they were incorporated into Ausf. B production. Similarly, Harkort fell behind once again in its production of eighteen Ausf. B hulls, and Eisen-und Hüttenwerke failed to deliver twelve Ausf. B hulls on schedule. In order to maintain delivery schedules, Krupp assembled thirty Ausf. B chassis, numbers 80213 through 80242, with Ausf. C hulls which were on hand in order to begin the next series production immediately. Thus it is that of the forty-two Ausf. B tanks ordered, only seven were actually completed with Ausf. B hulls.

Krupp-Grusonwerk completed and delivered a total of forty-two Pz. Kpfw. IV Ausf. Bs between May and October 1938. Some of the principal improvements over the Ausf. A included flat frontal armor for the driver and radio operator; an increase in the frontal armor of the bow, driver's compartment, and turret from 14.5 mm to 30 mm; a new cupola with 30 mm armor, twice that of the Ausf. A cupola; revamped, stronger visors for the sides of the superstructure and the turret; and splash guards on the superstructure roof around the base of the turret. *Patton Museum*

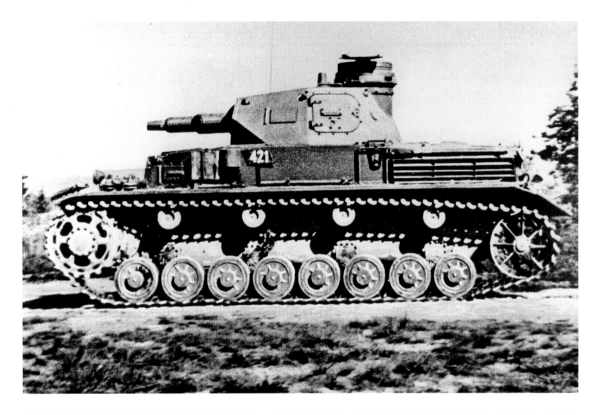

Before committing the Pz.Kpfw. IV Ausf. B to production, experiments were made with a wooden mock-up of the front part of the superstructure on the B.W.II test vehicle. The mock-up incorporated the straight frontal plate of the superstructure, along with rough simulations of a driver's sliding visor and a radio operator's vision port, to the right of which was a round pistol port. *Patton Museum*

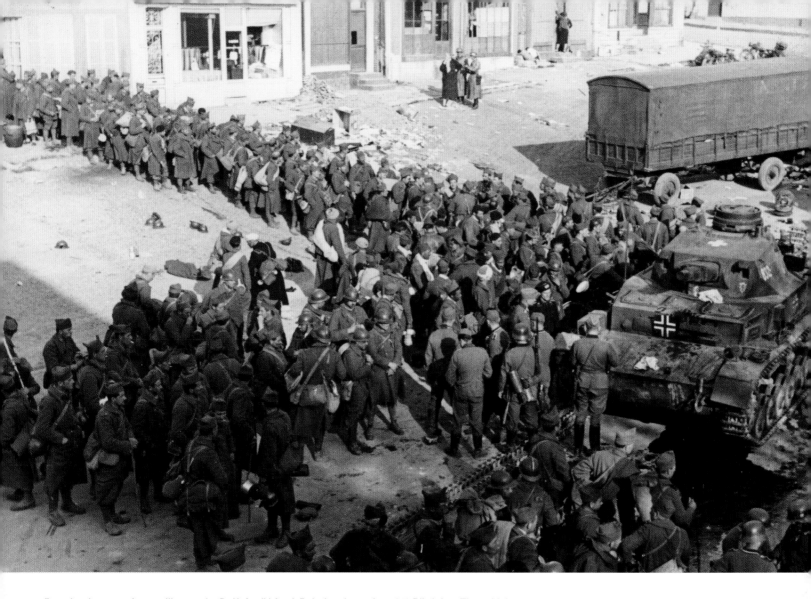

French prisoners of war mill around a Pz.Kpfw. IV Ausf. B during the spring 1940 Blitzkrieg. The vehicle has the symbol of the 1st Panzer Division on the left frontal plate of the turret. Vehicle number 832 is on the side of the turret, and two styles of *Balkenkreuz* are present: the white-outlined style on the frontal plate and a solid white one on the turret roof. This Pz.Kpfw. IV Ausf. B was undergoing a track change at the time it was photographed: notice the length of track on the ground in front of the right suspension. An important feature of the Pz.Kpfw. IV Ausf. B (and Ausf. C) was the omission of the bow machine gun, with a vision port located in that position. *National Archives and Records Administration*

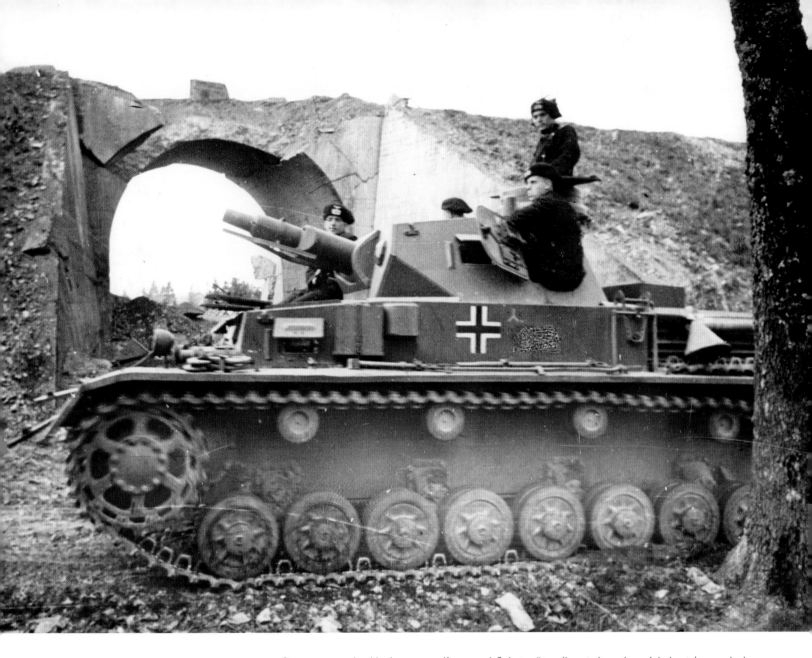

Crewmen wearing black panzer uniforms and *Schutzmützen* (beret-shaped crash helmets) are enjoying a few moments of fresh air during a campaign. To the upper rear of the white and black *Balkenkreuz* is the yellow symbol of the 5th Panzer Division in 1940: an inverted letter Y with a dot to its lower right. The relative thinness of the turret door is apparent: the turret side and rear armor was 14.5 mm thick. Fitted to the 7.5 cm gun barrel is an antenna deflector. *National Archives and Records Administration*

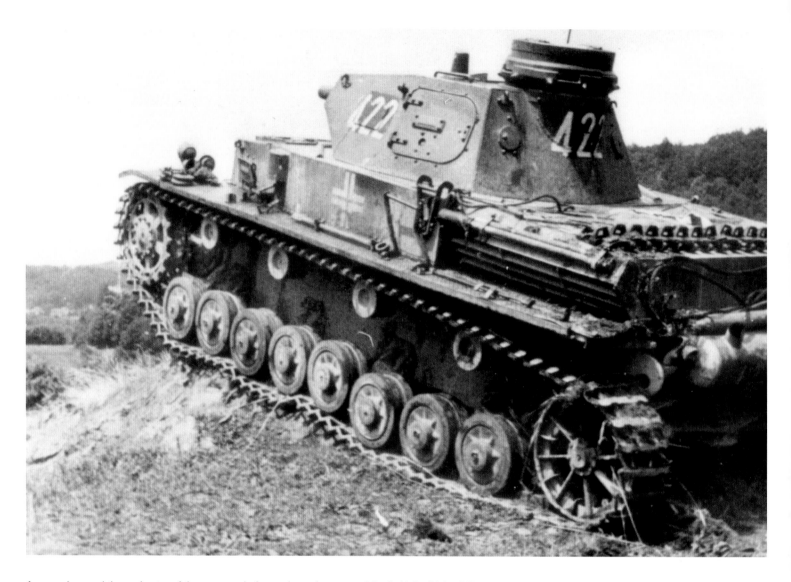

Arranged around the perimeter of the commander's cupola on the turret of the Pz.Kpfw. IV Ausf. B were five shutter-type visors with sliding upper and lower elements. The cupola hatch was a round, two-piece unit. A circular pistol port was on the rear of the turret to each side of the cupola. To the side of the engine deck is the louvered intake for engine-cooling air, with a bore-cleaning brush and staff above it. A similar louvered structure on the opposite side of the vehicle was a cooling-air outlet. To the front of the bore-cleaning brush is a boarding ladder. *National Archives and Records Administration*

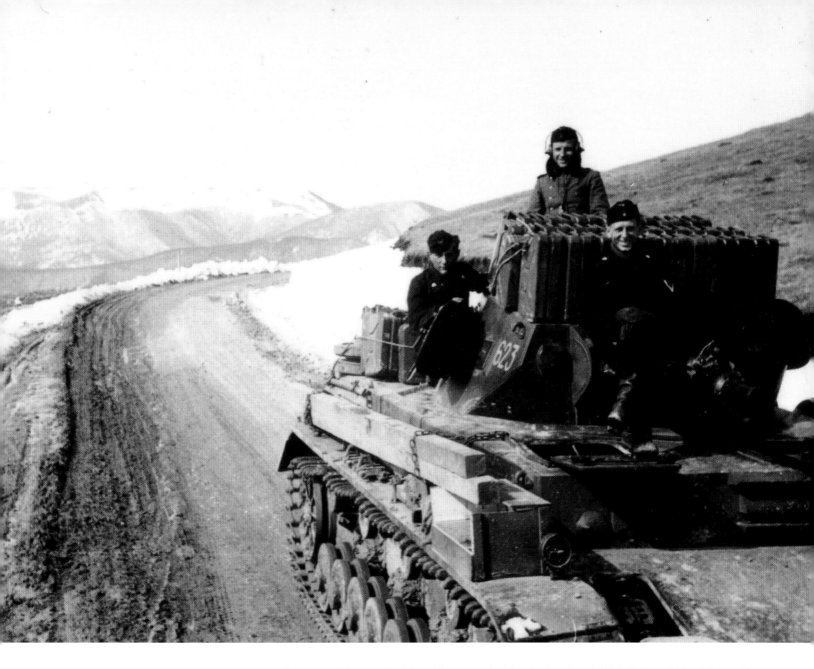

Two rows of Jerrycan liquid containers are stored on the turret roof of this Pz.Kpfw. IV Ausf. B operating in mountainous terrain. More Jerrycans are secured to the engine deck behind the turret. The vehicle number 623 painted on the side of the turret indicated this was the 3rd vehicle of the 2nd Platoon of the 6th Company. Two wooden beams for use in unditching are chained to the right fender, along with a non-standard wooden box. *National Archives and Records Administration*

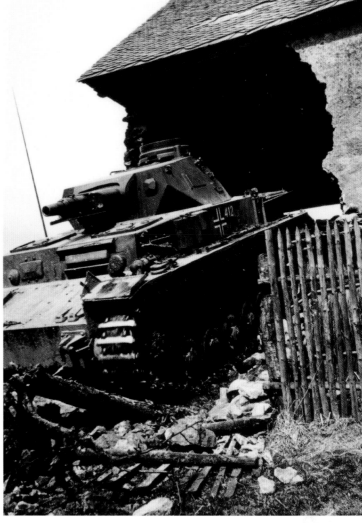

The commander of a Pz.Kpfw. IV Ausf. B is standing in the cupola hatch, with the left panel of the split hatch open to his side. A sighting vane is on the front of the ring at the base of the cupola. A crash pad is on the inside of the hatch. To the lower right are a hood for the left signal port and a grab handle. The hood for the left signal port had its genesis during the planning stages of the Ausf. B on direct orders from Wa Prüf 6, the automotive-design office of the Ordnance Department. To the lower left is the turret-roof ventilation flap. In the background is an uparmored, early-model Pz.Kpfw. II. *National Archives and Records Administration*

A Pz.Kpfw. IV Ausf. B is positioned in the blown-out corner of a house. The multifaceted left observation port in the front of the turret, a feature introduced with the Ausf. B, is evident: this feature carried over to subsequent models of the tank. This vehicle has a rain guard over the driver's visor. The radio operator's round, conical pistol port is to the right of the radio operator's front vision port. *National Archives and Records Administration*

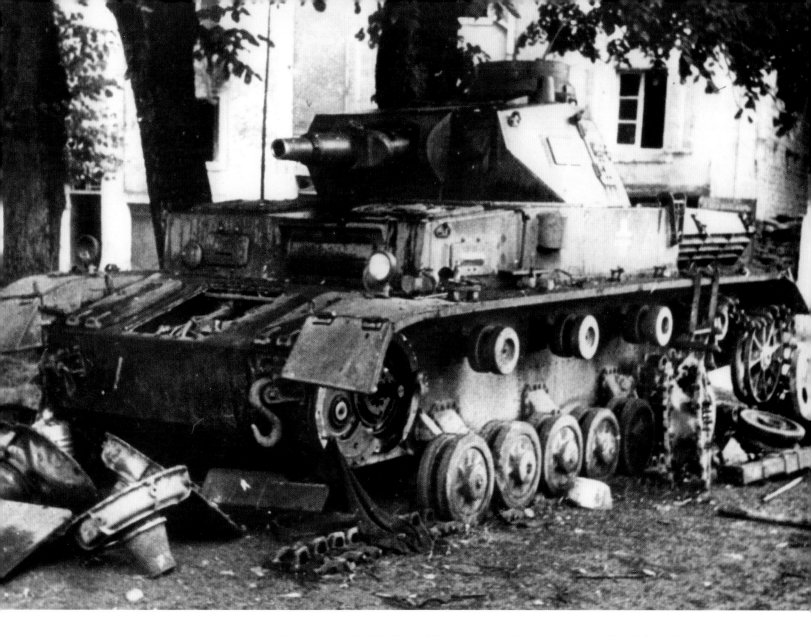

A knocked-out Pz.Kpfw. IV Ausf. B sits on a street in a populated area. The left final drive was blown off and is lying in front of the tank. The left sprocket is lying near the rear of the suspension, and the rear bogie and road wheels were blown off. A white *Balkenkreuz* is faintly visible on the side of the superstructure. No antenna deflector is present on the gun barrel.
National Archives and Records Administration

CHAPTER 3
Panzer IV Ausf. C

Ausf. C 3.series B.W. (Begleitwagen)	
Make	Krupp Grusonwerk
Chassis (Fgst) number	80301-80440
Quantity	140
Dimensions	
Length	19′ 5.07″
Width	9′ 3.42″
Height	8′ 9.51″
Wheelbase	7′ 10.9″
Track contact	11′ 6.58″
Weight	40,793 pounds
Automotive	
Engine	Maybach HL120TRM
Configuration	V-12, water-cooled
Displacement	11.9 liters
Power output	265 hp @ 2600 rpm
Fuel capacity	124 gallons
Transmission	ZF S.S.G.76
Speeds	6 + reverse
Steering	differential
Track	Kgs 6110/380/120
Links per side	99
Performance	
Crew	5
Max speed	26 mph
Cruising speed	15.5 mph
Cross-country	12.5 mph
Range, on-road	130 miles
Range, cross-country	80 miles
Fording depth	31.5″
Trench crossing	7.5′
Armament	
Main gun	7.5 cm Kw.K. 37 L/24
Range	2,000 meters
Coaxial	7.92 mm MG 34
Elevation	-10 to +20 degrees
Ammo, 7.5 cm	80 rounds
Ammo, 7.92 mm	2,500 rounds

As was the case with the Ausf. B, the contract for the Ausf. C variant was awarded even before the first Ausf. A had been completed. The October 1937 order called for 140 vehicles, chassis numbers 80301 through 80440, of the 3.Serie/BW to be built. At that time it was intended that these vehicles would use a different chassis than had been previously used. The Ausf. C was to have used the torsion bar-equipped chassis being developed by Daimler-Benz for their production of the Panzer III Ausf. E. Accordingly, on June 1, 1937, the army design office ordered Krupp to cease further development of the Panzer IV chassis.

However, there were numerous delays in the production of the new chassis, with Erich Woelfert reporting Daimler's situation on May 2, 1938: "The major setback was caused by using newly designed components that were insufficiently tested … series production won't occur for the foreseeable future."

In order to keep the Panzer IV in continuous production, the decision was made to build the Ausf. C on the same type of chassis as the Ausf. B, with only minor changes being permitted by the government.

Among the few changes allowed was the use of an improved engine. While the first forty Ausf. C chassis were assembled with the same type HL 120 TR engine as the Ausf. B, the balance of the Ausf. C were equipped with the improved HL 120 TRM. As before, HL designated *Hochleistungsmotor* (high performance motor), while the TR signified *Trockensumpfschmierung*, or dry sump lubrication. The addition of the M indicated that the engine was equipped with a *Schnappermagnet*, or magneto ignition. The addition of magneto ignition not only improved reliability; it meant that if necessary the engine could be started using hand cranking and would run devoid of outside (battery or generator) electrical power.

Beyond the change in engine, much more visible improvements to the Ausf. C include an armored sleeve for the barrel of the coaxial MG 34 and a reshaping of the top leading edge of the mantlet.

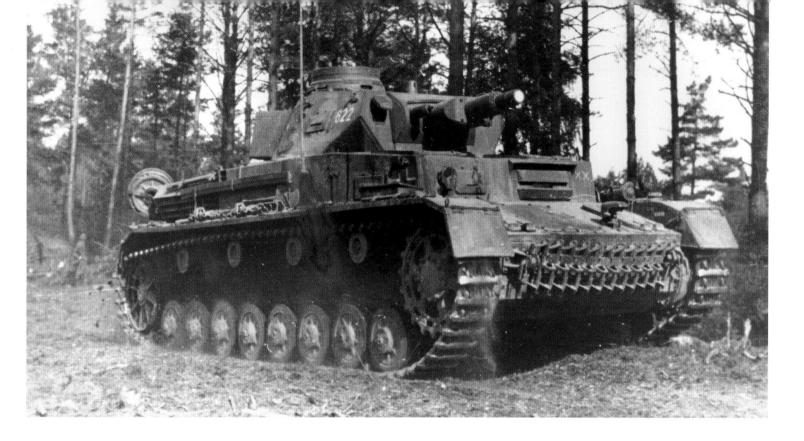

Production of the Ausf. C began in October 1938, and ran through August 1939. Once again, some tanks were built using the hulls intended for different ausführung, or types. The manufacturers were directed to modify the thirty Ausf. B hulls that were not delivered in time for use on their intended chassis in order to make them Ausf. C standards. These were then used in Ausf. C production. Also, secret orders issued on February 22, 1939, directed that the last six Ausf. C chassis be assembled without turrets for use in creating armored bridge layers. These test vehicles were delivered in February 1940. One of these, chassis 80436, was returned to Krupp the month after March 1940 testing for completion as a standard Panzer IV Ausf. C. A similar decision was made in June concerning three more of the bridge layers, leaving only 80435 and 80438 being retained as bridge layers. The three bridge layers converted to tanks beginning in July 1940 were equipped with Ausf. E bow armor and Ausf. C turrets, rear armor, and chassis.

A few minor changes were made during the production, including the introduction of the Panzer III commander's cupola beginning with the thirty-first turret and welding a rain deflector over the driver's visor beginning with the fifty-eighth vehicle.

Production of the Panzer IV through the Ausf. C totaled 217 vehicles, of which 211 were initially delivered as tanks. One hundred ninety-eight of these were used in the invasion of Poland in September 1939, with the balance held in depot storage or being used as training vehicles. Generally, the performance of the vehicles was pleasing to both their crews and the army command, although nineteen of the vehicles subsequently required complete overhaul. However, the experience did highlight some weaknesses of the design that would be addressed in future Ausführung.

Externally, the Pz.Kpfw. IV Ausf. C, of which 140 were completed (134 with turrets and six as bridge layers) was very similar to the Pz.Kpfw. IV Ausf. B. The most visible difference was that the Ausf. C had a prominent armored sleeve over the muzzle end of the coaxial 7.92 mm MG 34. This example is marked with the "XX" symbol of the 6th Panzer Division from 1941 to 1945 to the left of the driver's visor and the number 622 on the side of the turret. A Notek blackout headlight is on the front of the glacis. The vision port to the right of the mantlet is open. *Patton Museum*

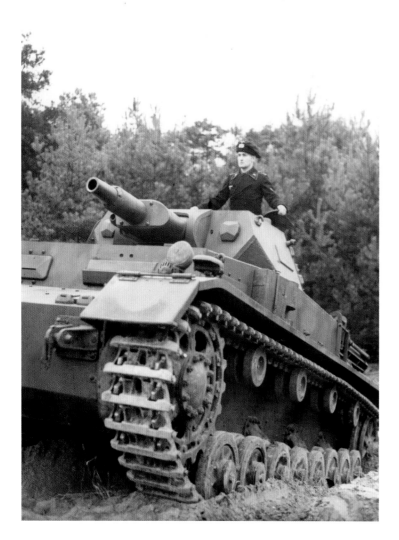

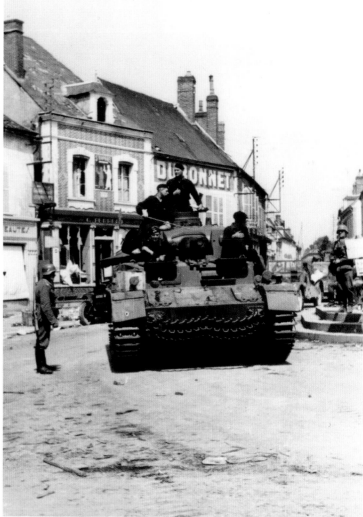

The armored sleeve for the coaxial machine gun is visible to the right side of the external mantlet on this Pz.Kpfw. IV Ausf. C. A close examination of this photo and others of the Ausf. C reveals that vertical ridges were incorporated into the side of the external mantlet. This apparently was to deflect bullets and splinters from hitting the gunner's sight aperture to the left of the external mantlet. A Notek blackout headlight is to the side of the service headlight on the fender. *National Archives and Records Administration*

The crew of a Pz.Kpfw. IV Ausf. C relax during the 1940 Blitzkrieg campaign against France and the Low Countries. The yellow "XX" insignia of the 9th Panzer Division used during the 1940 campaign is on the upper left of the driver's frontal plate. The 7.5 cm gun is fitted with the muzzle plug often seen inserted in the piece when not in use, to keep dust, moisture, and foreign objects out of the barrel. *National Archives and Records Administration*

A crewman peeks out of the right door of the turret of a Pz.Kpfw. IV Ausf. C of the 8th Panzer Division during a pause next to a river crossing. To the left of the driver's visor of the tank in the foreground is the divisional symbol used from the 1941 invasion of the Soviet Union on: a Y with a vertical bar to the right. Like the Pz.Kpfw. IV Ausf. B, the Ausf. C had single-piece driver's and radio operator's hatches. Each hatch had a round signal port in it. Sitting on the right fender is a funnel. The lower half of the *Balkenkreuz* is painted on the radio-antenna holder. Both vehicles have spare road wheels stored on each side of the turrets. *Patton Museum*

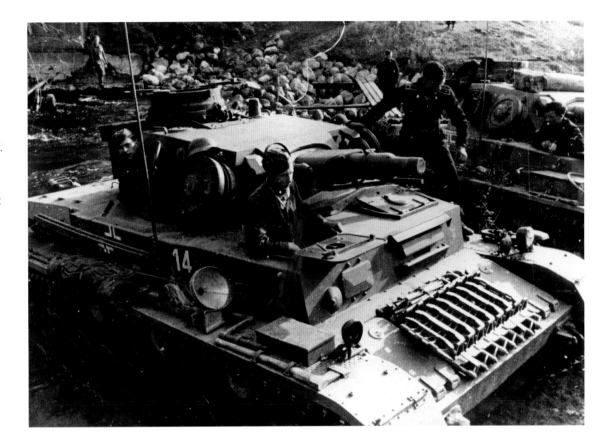

A Pz.Kpfw. IV Ausf. C crosses railroad tracks during operations in the winter. To the rear of the *Balkenkreuz* on the superstructure is a rhomboid placard with the vehicle number, 414 (4th vehicle, 1st Platoon, 4th Company) painted on it. Faintly visible to the rear of that placard is the symbol of the 6th Panzer Division in 1940: an inverted Y with two dots to the right of it. The 7.5 cm gun is fitted with an antenna deflector, and a section of spare track is stored against the side of the engine compartment. *Patton Museum*

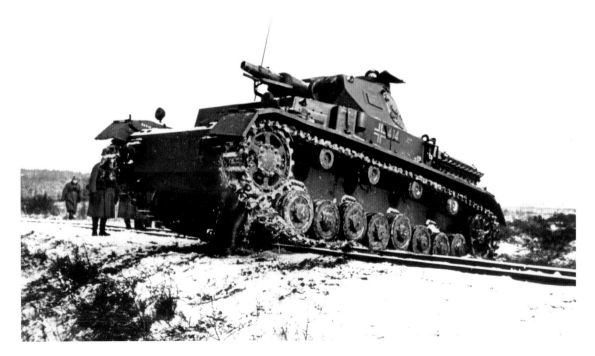

6. Panzer Division troops stand at attention next to a Pz.Kpfw. IV Ausf. C during an inspection in late summer 1941; an MG 34 is lying on the bench to the front of the tank. An unusual storage box is on the left fender, partially hiding a *Balkenkreuz* on the superstructure. A nonstandard brace for the fender is to the rear of the driver's side visor, no doubt to help support the extra weight of the box. On the turret is the red-devil insignia of Panzer Regiment 31, while on the superstructure is a single yellow X, the symbol of the 5th Panzer Division. In the background are a Pz.Kpfw. II and another Pz.Kpfw. IV. *National Archives and Records Administration*

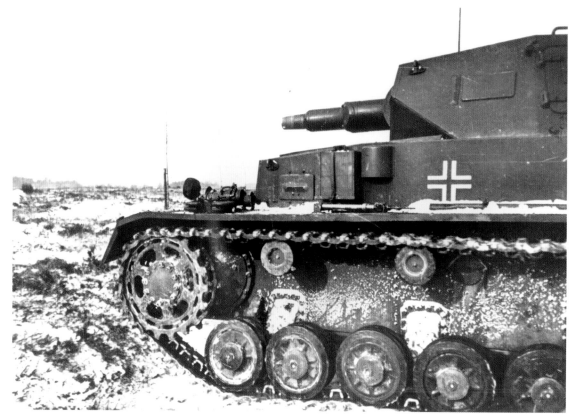

This vehicle is a Pz.Kpfw. IV Ausf. C, based on information from other photographs of the same tank. On the fender are the left headlight, fire extinguisher, s-hooks, and wire cutters. A clear view is available of features on the forward part of the side of the superstructure, including the driver's side port, the jack block, and the steering-brakes air outlet. *Patton Museum*

"Hedi" is painted on the top part of the driver's visor of this 21. Panzer Division Pz.Kpfw. IV Ausf. C, photographed in St. Martin de Fresnay in June 1944. A loose-fitting blackout cover with a slot in it is to the right side of the Notek blackout headlight on the left fender. To the immediate rear of the headlights is a C-hook in a holder. A nonstandard holder of some sort, made of thin metal strap, is jutting out from the side of the forward part of the superstructure. *National Archives and Records Administration*

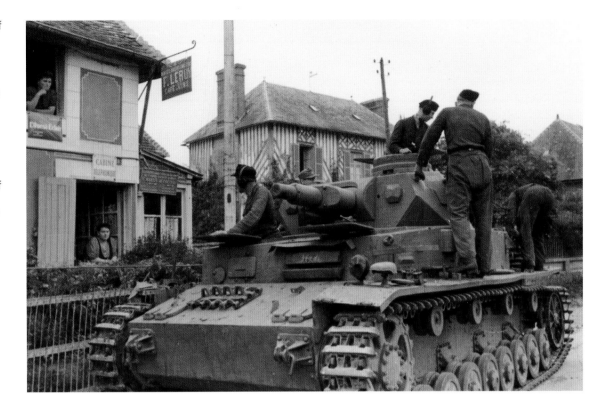

The storage box on the rear of the turret was a modification introduced in early 1941. A clear view is available of the rear of the hull, including the muffler, which extended nearly the whole width of the hull. Also clearly visible are the three horizontal louvers and the two vertical spacers of the cooling-air inlet. With the next model of Pz.Kpfw. IV, the Ausf. D, the number of horizontal louvers would be reduced to two. *National Archives and Records Administration*

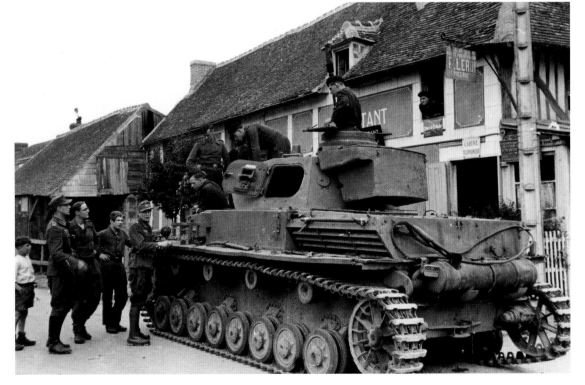

CHAPTER 4
Panzer IV Ausf. D

Ausf. D	
Make	Krupp Grusonwerk
Chassis (Fgst) number, 4.series B.W.	80501-80700
Chassis (Fgst) number, 5.series B.W.	80701-80748
Quantity, 4.series B.W.	200
Quantity, 5.series B.W.	48

Dimensions	
Length	19' 5.07"
Width	9' 3.42"
Height	8' 9.51"
Wheelbase	7' 10.9"
Track contact	11' 6.58"
Weight	44,100 pounds
Automotive	
Engine	Maybach HL120TRM
Configuration	V-12, water-cooled
Displacement	11.9 liters
Power output	265 hp @ 2600 rpm
Fuel capacity	124 gallons
Transmission	ZF S.S.G.76
Speeds	6 + reverse
Steering	differential
Track	Kgs 6111/380/120
Links per side	99
Performance	
Crew	5
Max speed	26 mph
Cruising speed	15.5 mph
Cross-country	12.5 mph
Range, on-road	130 miles
Range, cross-country	80 miles
Fording depth	31.5"
Trench crossing	7.5'
Armament	
Main gun	7.5 cm Kw.K. 37 L/24
Range	2,000 meters
Coaxial	7.92 mm MG 34
Elevation	-10 to +20 degrees
Ball mount	7.92 mm MG 34
Ammo, 7.5 cm	80 rounds
Ammo, 7.92 mm	2,700 rounds

In July 1938, Krupp was awarded a contract to produce 200 of the Fourth Series Begleitwagen, (4.Serie/BW), or Panzer IV Ausf. D. Production of these vehicles would begin in October 1939, yet an additional order for forty-eight identical vehicles, designated 5.Serie/BW but retaining the Panzer IV Ausf. D designation, was placed in December 1938. These forty-eight vehicles were intended to equip four Waffen-SS regiments with medium tank companies. Although beginning in January 1940, these vehicles were produced at a rate of five per month concurrently with the 4.Serie tanks, they were not issued to the SS as intended but rather supplied to the army, with the Waffen-SS getting Sturmgeschütz instead.

The introduction of the Ausf. D brought with it a number of changes. A new model of tank track was used, with a taller guide horn. The number of suspension bump stops was increased to one bump stop per bogie, with an additional stop behind the rear pair of road wheels. Previously these were only installed in conjunction with the front and rear road wheels.

Much more apparent was the return of the setback radio operator's position with a ball-mounted machine gun. The setback was obvious, but less obvious was the increase in armor thickness of the hull front, rear, and side armor from 14.5 mm to 20 mm. The frontal armor of the superstructure was increased to 30 mm, and began to be made of face-hardened PP494 cemented armor plate. It should be recognized that the term "cemented," as applied to steel plates and armor, means carburizing, or introducing carbon into the steel after the plate has been formed. This molecular carbon is deposited most heavily near the surface of the plate, and gradually less toward the center of the cross-section. The result is a plate that is hard on the surface, yet remains malleable enough that it will deform, rather than shatter, when struck. The Ausf. D also utilized a newly designed external mantlet that was 35 mm thick, a 5 mm increase over that of the Ausf. C.

After experience in Poland, even this was deemed inadequate, and on December 18, 1939, the army requested that Krupp increase the frontal armor even further. The request specified that the last sixty-eight Ausf. D hulls be equipped with 50 mm thick homogenous PP794 armor. In July of 1940, Krupp began installing supplemental armor plates, 20 to 30 mm thick, on the hull front and sidewalls. These were held in place by screws. The army intended to retrofit this armor to previously delivered vehicles as well.

Despite orders having been placed for a total of 248 Panzer IV Ausf. D, initially only 232 were produced. The remaining sixteen chassis had been earmarked for use in constructing bridge layers. After these had been completed in May 1940, the army reversed its decision and issued orders that these vehicles were to be converted to gun tanks.

As production of the Ausf. D neared the end in October 1940, at least one vehicle was assembled using Ausf. E bow armor, but the details of this remain unclear. During July and August 1940, forty-eight of the Ausf. D models were outfitted with deep water fording, or *Tauchpanzer*, gear in anticipation of the planned invasion of Britain. Earlier the same year a slightly smaller quantity had been equipped with tropical gear (*Tropen*) for deployment to North Africa. While the *Tropen*-equipped tanks were used as planned, the invasion of Britain did not occur. The only known use of Germany's submersible tanks as such was the crossing of the River Bug at Patulin on June 22, 1941, during Operation Barbarossa.

The Grusonwerk-manufactured Pz.Kpfw. IV Ausf. D was distinguished from the Ausf. C by several external details, the most noticeable of which were the stepped, not straight, driver's and radio operator's frontal armor, now with a ball-mounted machine gun, and the two horizontal louvers instead of three on the air intake and air outlet on the sides of the engine compartment. The face-hardened frontal armor of the superstructure and the bow was 30 mm thick and proof against 2 cm armor-piercing projectiles. The internal/external mantlets of previous models were discarded in favor of an external mantlet. *National Archives and Records Administration*

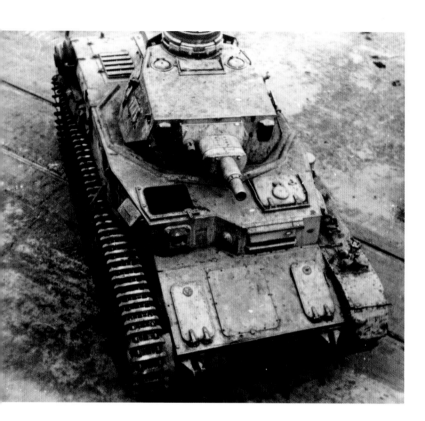

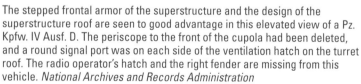

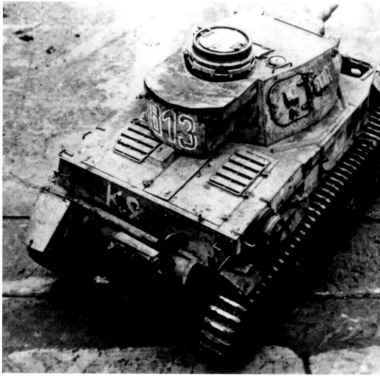

The stepped frontal armor of the superstructure and the design of the superstructure roof are seen to good advantage in this elevated view of a Pz. Kpfw. IV Ausf. D. The periscope to the front of the cupola had been deleted, and a round signal port was on each side of the ventilation hatch on the turret roof. The radio operator's hatch and the right fender are missing from this vehicle. *National Archives and Records Administration*

The same Pz.Kpfw. IV Ausf. D is viewed from the right rear. The Ausf. D retained the wide muffler of the preceding models. This tank was equipped with the "*Tropen*" kit for operating in hot climates such as North Africa, including the revised engine-access doors with a ventilation grille on each one. On each side of the rear of the superstructure is a holder for a spare road wheel. The splashguard on the superstructure roof to the right side of the turret is visible; the splashguards deflected bullets and splinters that might jam the base of the turret and prevent it from traversing. *National Archives and Records Administration*

The Bison insignia of the 7th Panzer Regiment, 10th Panzer Division, is stenciled on the side of the turret to the front of the vision port on this Pz.Kpfw. IV Ausf. D. This model of the tank retained the boarding ladder on the side of the superstructure to the front of the engine compartment. The upper and lower sliding rings on the cupola are in the "open" position, thus uncovering the vision slots, one of which is visible on the left side. *National Archives and Records Administration*

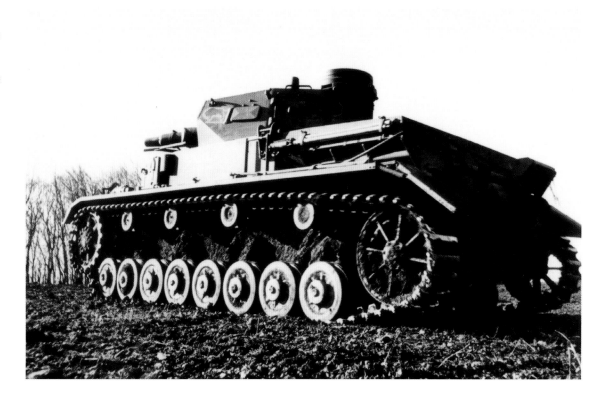

The commander and a crewman of a Pz.Kpfw. IV Ausf. D intently observe the terrain to the front. The disassembled rammer staff and brush are stored on the side of the engine compartment above the engine cooling-air intake. A nonstandard storage box is on the left fender. Above the front end of that box on the side of the superstructure is a semi-cylindrical object: this was the armored cover for the exhaust outlet for the steering brakes and gearbox and was a standard item on all models of the Pz.Kpfw. IV. *National Archives and Records Administration*

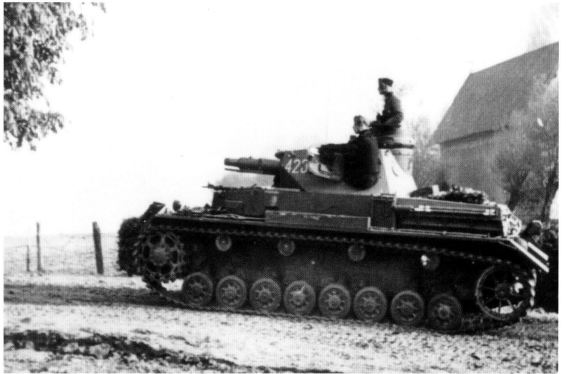

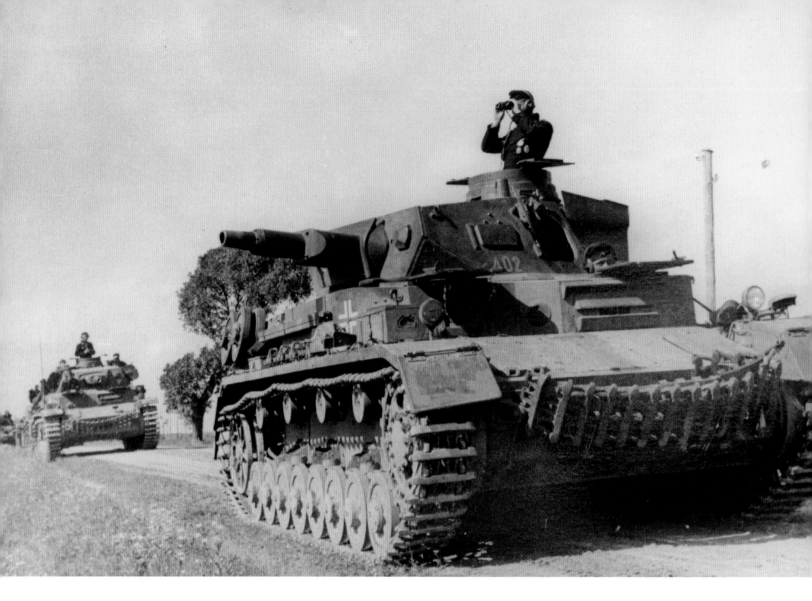

The commander of a Pz.Kpfw. IV Ausf. D scans through his binoculars the right flank of a column of 6th Panzer Division tanks during Operation Barbarossa, the invasion of the Soviet Union in the summer of 1941. The tank's individual number, 402, is in small numerals on the side of the turret below the vision port. A clear view is available of the external mantlet, which was 35 mm in thickness. Two road wheels are in a holder on the side of the rear of the engine compartment. *National Archives and Records Administration*

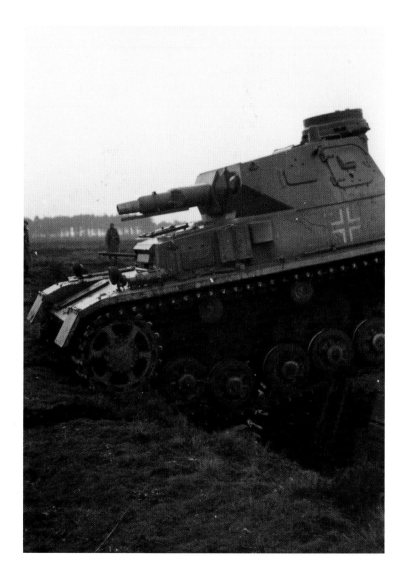

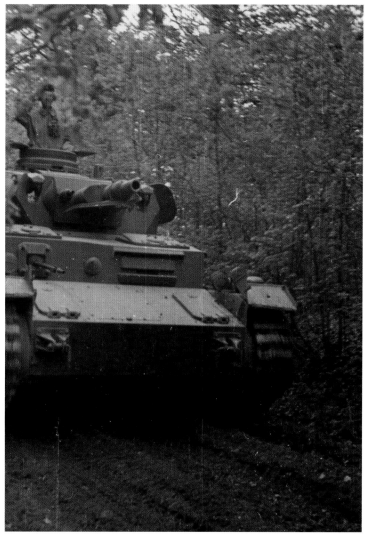

A Pz.Kpfw. IV Ausf. D drives over an entrenchment during a training exercise. A fire extinguisher is clamped to the fender to the rear of the headlight. The antenna deflector was attached to the sleeve of the 7.5 cm gun by a clamp-type metal band. Above the driver's visor is the rain guard. The access door for the right steering brake stands above the glacis; the left door was similarly situated with reference to the glacis.
National Archives and Records Administration

The observation ports to the sides of the 7.5 cm mantlet are open on this Pz. Kpfw. IV Ausf. D. The antenna deflector's original shape was revised for the Ausf. C, with the right rear of the device being extended to the rear to prevent the antenna from snagging on the armored sleeve of the coaxial machine gun, and this design carried over to the Ausf. D. The two access doors for the steering brakes sat above the glacis, while the access panel between them for the gearbox was flush-mounted.
National Archives and Records Administration

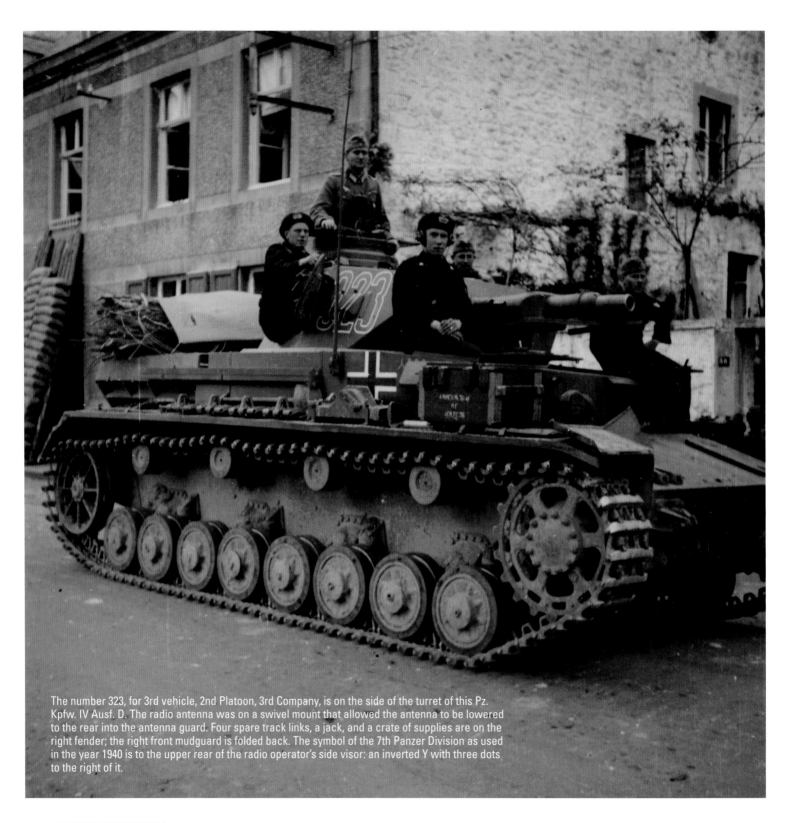

The number 323, for 3rd vehicle, 2nd Platoon, 3rd Company, is on the side of the turret of this Pz. Kpfw. IV Ausf. D. The radio antenna was on a swivel mount that allowed the antenna to be lowered to the rear into the antenna guard. Four spare track links, a jack, and a crate of supplies are on the right fender; the right front mudguard is folded back. The symbol of the 7th Panzer Division as used in the year 1940 is to the upper rear of the radio operator's side visor: an inverted Y with three dots to the right of it.

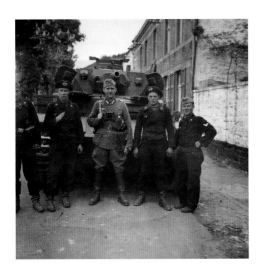

The same crew seen in the preceding photograph poses in front of the same Pz.Kpfw. IV Ausf. D at the identical location, displaying a mix of uniforms and headgear. The officer at the center, who was in the commander's cupola in the preceding photo, is wearing a *Heer* uniform with a Nazi Party Badge on the left tunic pocket and campaign ribbons above the pocket. The other men are wearing the black Panzer uniform with death's-head collar patches. The multifaceted right observation port on the turret front is in the open position, while the left port is closed. *National Archives and Records Administration*

A cameraman is filming from the engine deck of a Pz.Kpfw. IV Ausf. D as its 7.5 cm gun is being fired. Two specific features identify this vehicle as an Ausf. D: the sprocket with oblong holes around the rim inside the teeth, which was replaced by a new style of sprocket without the holes starting with the Ausf. E; and the presence of the external mantlet. The shovel is stored on the side of the superstructure below the antenna holder; here, the antenna is lowered into the holder. *National Archives and Records Administration*

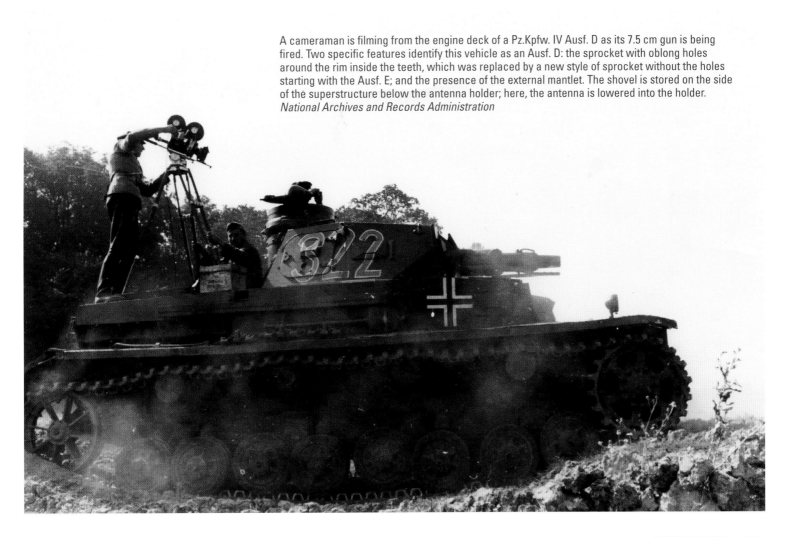

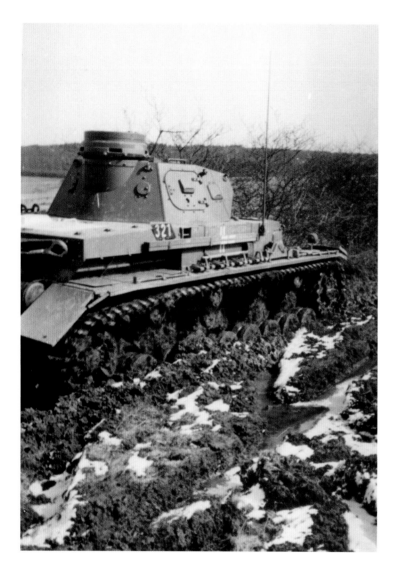

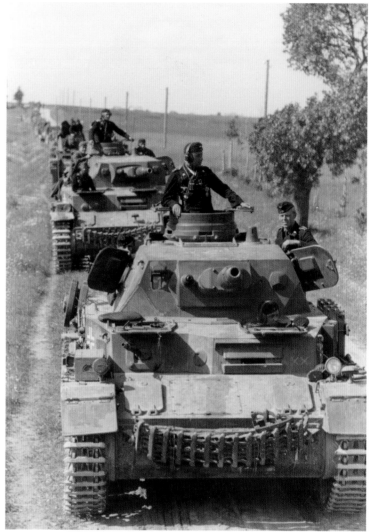

A Pz.Kpfw. IV Ausf. D negotiates an extremely muddy stretch of ground. The vehicle number, 321, is on a rhomboid placard on the side of the engine compartment. The white *Balkenkreuz* is spread out between the superstructure and the antenna guard. The loop end of a tow cable is attached to a hook on the upper rear plate of the engine compartment. *National Archives and Records Administration*

A Pz.Kpfw. IV Ausf. D precedes an armored column during a road march. The "XX" symbol of the 6th Panzer Division from 1941 on is faintly visible to the left of the driver's visor. Four Jerrycans are stored on the left fender to the rear of the jack block. The second vehicle in line is a Pz.Kpfw. IV Ausf. C: notice the straight frontal plate of the superstructure and the vision port in lieu of a ball-mounted machine gun. Both side doors of the turret are open. *National Archives and Records Administration*

A Pz.Kpfw. IV Ausf. D with no visible markings advances through a clearing in a wooded area. On the frontal plate of the bow are two tow fittings, with bent pins for securing tow cables. A section of spare track is stored against the driver's side vision port. No antenna deflector is installed on the 7.5 cm gun. The fronts of the fenders are bent, especially the right one. *National Archives and Records Administration*

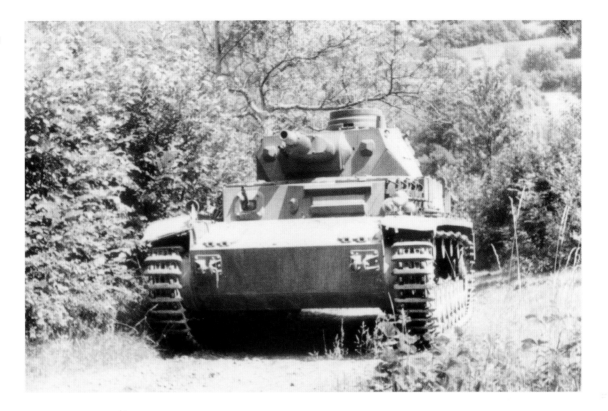

A knocked-out Pz.Kpfw. IV Ausf. D rests along a dirt road. The right steering-brake access door is missing, and the outboard hinge for the door has been blown off the glacis. The left access door lies open. On the side of the turret and on the turret door are vision ports with vision slits backed by thick glass to protect the crew from splinters entering through the slits. *National Archives and Records Administration*

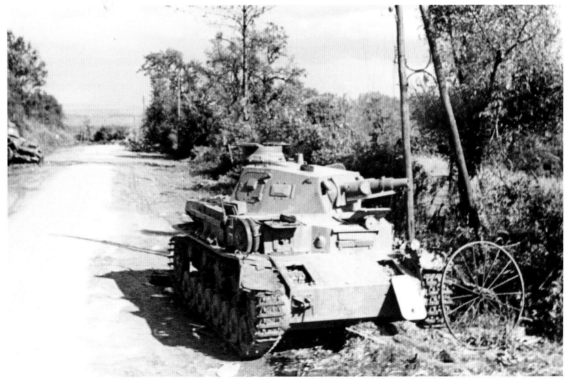

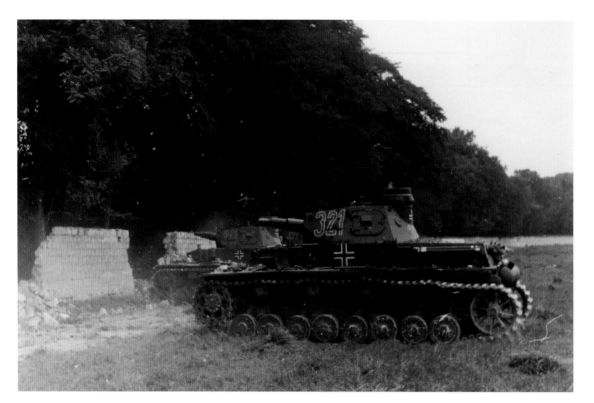

Two Pz.Kpfw. IV tanks prepare to pass through breaches in a stone wall during a training exercise. The nearest vehicle is an Ausf. D, as indicated by the presence of both the pre-Ausf. E sprockets with oblong holes and the two-louver engine-air intake on the side of the engine compartment. In addition, the road wheels have the hubs of the type used on the Ausf. D, after which the design was changed. *National Archives and Records Administration*

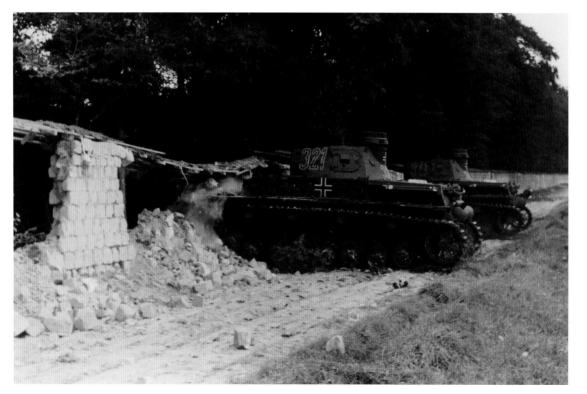

The nearest tank in the preceding photo, number 321, has butted into the stone wall while its neighbor, number 341, stands by. The vehicle numbers are painted on the sides and the rears of the turrets. The second tank has two horizontal louvers alongside the engine compartment, indicative of an Ausf. D or later model. *National Archives and Records Administration*

Number 321 has breached a stone wall and is charging ahead. Attached to the top of the muffler is a smoke-grenade discharger rack. The muffler is well battered; the tailpipe is on the top left of the unit. A tow cable is wound around and attached to hooks on the upper rear plate of the engine compartment. A *Balkenkreuz* is on the rear of the turret. *National Archives and Records Administration*

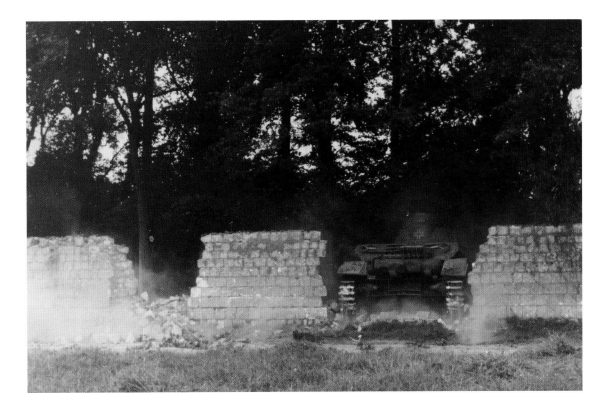

In this final photo of the series showing the Pz.Kpfw. IV Ausf. D numbered 321, the tank has halted on a slope. The vehicle is painted overall in *Dunkelgrau* (dark gray), the typical camouflage color used on German armor in the early part of World War II. In this photo it can be seen that the *Balkenkreuz* on this tank was black and white. Protruding from the roof to the front of the cupola is the hood for the left signal port. *National Archives and Records Administration*

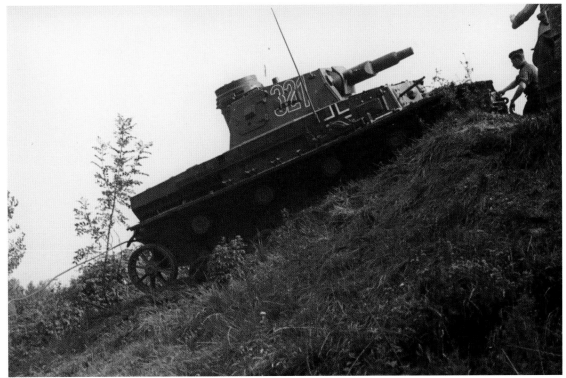

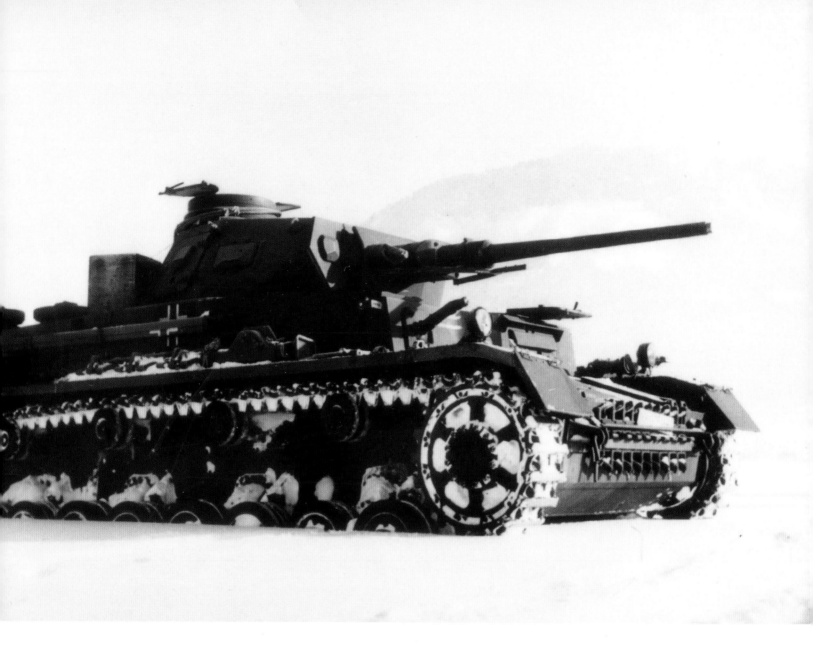

As the Wehrmacht began efforts to mount a more powerful gun than the short-barreled 7.5 cm KwK L/24 in the Pz.Kpfw. IVs, Hitler ordered a Pz.Kpfw. III and the vehicle shown in this photo, Pz.Kpfw. IV Ausf. D chassis number 80688, to be fitted as test beds for the 5 cm KwK L/60 gun. This vehicle was assembled and tested by Krupp at Essen, Germany, in early 1941, and it included revised ammunition storage and additional fuel tanks. It is shown here during testing at St. Johann in January 1942.
National Archives and Records Administration

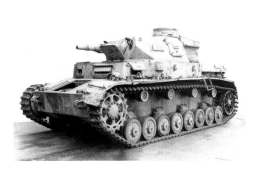

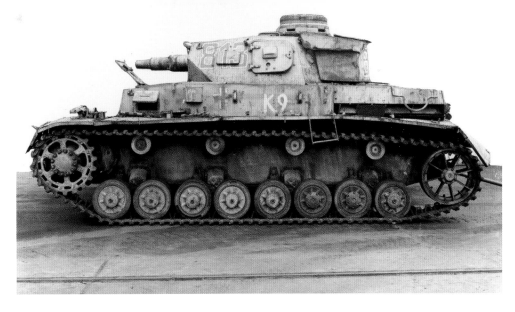

The subject of the following series of photos is a Pz.Kpfw. IV Ausf. D with an *Afrika Korps* palm tree and swastika symbol on the armored exhaust outlet for the steering brakes and gearbox, and the number 813 on the turret. The sprockets with the oblong openings around the perimeter are consistent with an Ausf. D vehicle. The forward five and the rear road wheels have the Ausf. D-style hubcaps, while the other two have Ausf. E-type hubcaps with six recessed screws around the perimeter. The gearbox cover is missing from the glacis. *Patton Museum*

Number 813 is observed from the left. Each of the track guide horns had cutouts: this feature is visible on some of the links between the idler and the rear road wheel and between the sprocket and the first road wheel. The damaged boarding ladder is hanging over the fender, which shows signs of battering. The storage bin on the rear of the turret, a postproduction modification added beginning in March 1941, did not fit very tightly to the turret. *Patton Museum*

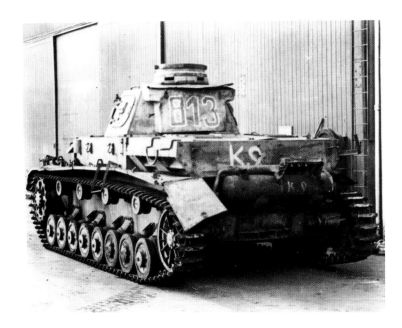

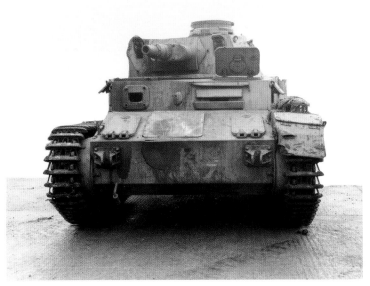

The Pz.Kpfw. IV Ausf. D numbered 813 is viewed from the left rear. The sliding rings on the cupola are parted so the vision slots are exposed. Toward the rear of the right side of the engine compartment is a holder with a spare road wheel. Mounted on the muffler is the smoke-grenade dispenser. *National Archives and Records Administration*

The Pz.Kpfw. IV Ausf. D numbered 813 was missing most of its right fender. A large, curved fracture was present in the center of the vertical armor of the bow. The L-shaped pin for the right tow bracket on the bow is dangling from its retainer chain. Three of the four conical-headed bolts that fasten the ball mount to the front of the superstructure are missing. A single conical-headed bolt is on the round pistol port to the left of the ball mount. *Patton Museum*

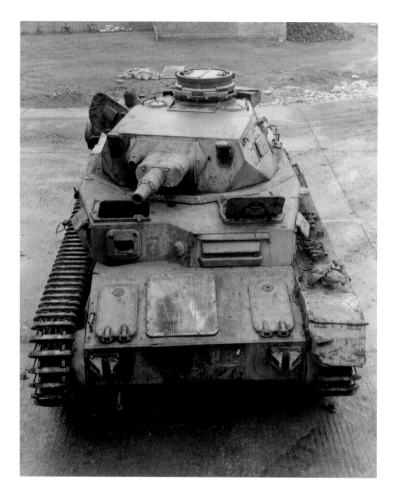

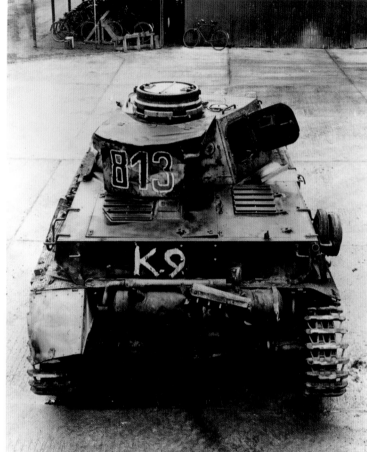

The *Afrika Korps* symbol of a palm tree and swastika is faintly visible between the ball mount and the pistol port on the front of the superstructure of number 813. The radio operator's hatch appears to have been blown off, and only the remnants of the left hinge remain attached to the superstructure roof. On the cupola, the vision slots to the left front and the right front are open, while the center-front slot is closed: the sliding top and bottom shutters of the open slots are out of alignment with the shutters of the closed slot. *Patton Museum*

Number 813 is viewed from above the rear, showing the twisted wreckage of the smoke-grenade dispenser mounted on the muffler. To the left and above the muffler is the exhaust and muffler for the DKW two-cylinder motor that drove a manifold generator for powering the turret. That generator was located in the engine compartment. The turret also had a manual-operating capability. The grilles of the tropical kit are on the access doors on the engine-compartment roof. *Patton Museum*

A towbar is attached to the rear of the Pz.Kpfw. IV Ausf. D numbered 813. The left fender is bent upward at the center, and the rear mudguard is wracked. The edge of the tailpipe emanating from the upper left of the muffler is jagged, and there is a U-shaped bracket attached to the far right of the upper rear plate of the engine compartment. *Patton Museum*

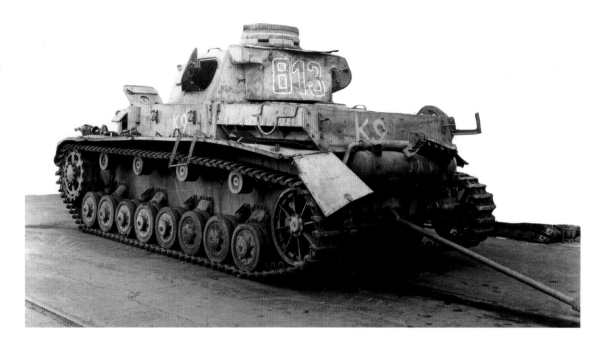

Some Pz.Kpfw. IV Ausf. Ds were rebuilt beginning in the summer of 1940, receiving Ausf. E-type sprockets (compatible with 40 cm tracks) and road wheels, supplemental armor on the sides and front of the superstructure, and other upgrades. A number of the rebuilt tanks subsequently were rearmed in 1942–43 with the 7.5 cm KwK 40 L/43 gun, with a much longer barrel than the original 7.5 cm KwK L/24. This example was captured by the Allies, and on the top rear plate of the engine compartment is a barely legible shipping stencil for Aberdeen Proving Ground. *National Archives and Records Administration*

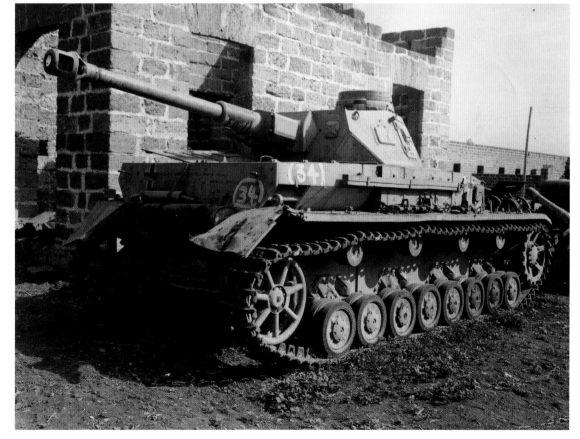

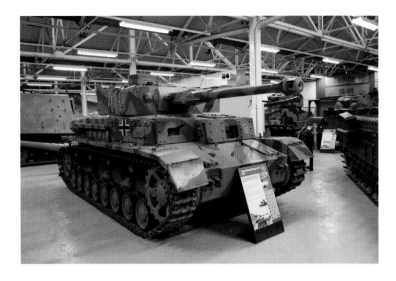

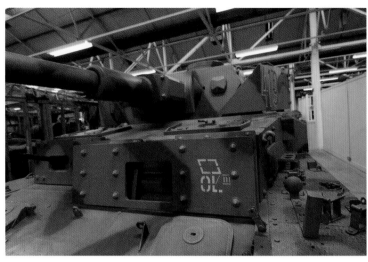

This Pz.Kpfw. IV Ausf. D, chassis number 80732, is displayed at the Tank Museum, Bovington, England. It was upgunned and modernized by the Germans in 1943, receiving a 7.5 cm KwK 40 gun and appliqué armor on the hull and superstructure. Turret skirting is also present. This tank was captured in Germany at the end of the war and donated to the museum in 1951. *Massimo Foti*

The supplemental armor on the front of the superstructure is viewed from the left front of the vehicle. On the fender in the foreground is a holder for a fire extinguisher, to the outboard side of which are two holders for S-type tow hooks. On the face of the turret is the multifaceted left observation port, to the right of which is the sight aperture. *Massimo Foti*

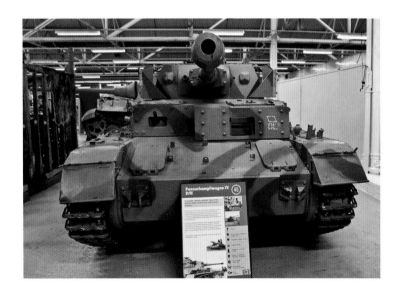

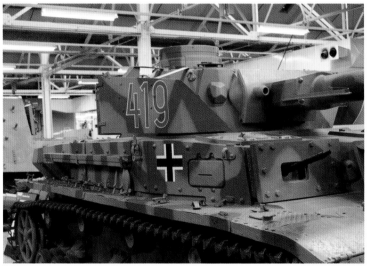

The 7.5 cm gun has an "acorn" muzzle brake of the type seen fitted from early 1942 to mid-1943. Supplemental armor with openings for the driver's visor and ball machine gun are bolted to the superstructure. The access doors for the steering-brake assemblies rest above the glacis, while the access plate for the differential is flush-mounted. *Massimo Foti*

Supplemental armor plates are attached to the sides of the superstructure with conical-head bolts. The armored sleeve for the coaxial machine gun is on the right side of the mantlet. Attached to the 7.5 cm gun is an antenna deflector. The swiveling antenna mount, minus the antenna, is present, as is the antenna holder above the fender. *Massimo Foti*

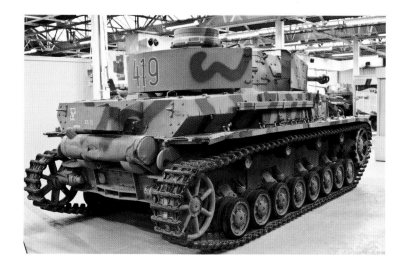

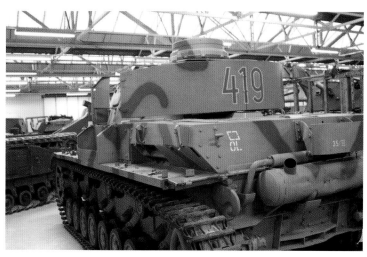

The doors of the turret skirting and the rear mud flaps are missing from the Bovington Pz.Kpfw. IV Ausf. D. Above the muffler is the armored guard for a smoke-grenade dispenser. On the upper rear plate of the engine compartment are two hooks for storing a tow cable. Tow fittings in the form of inverted hooks are on each side of the muffler. *Massimo Foti*

Details on the rear of the Pz.Kpfw. IV Ausf. D are displayed. A vertical joint is at the center rear of the turret skirting, along the center of the numeral 1 in the tactical number 419. Two of the sheet-metal doors for the engine-air exhaust louvers is in the closed position; the other two doors are missing. The doors usually were closed in cold weather. *Massimo Foti*

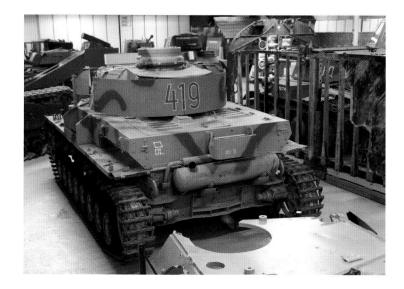

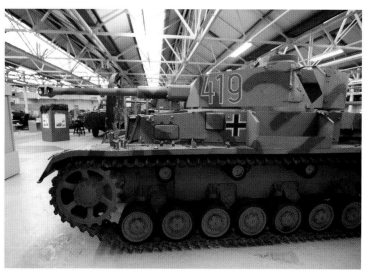

An upper rear view of the vehicle reveals the exhaust pipe and muffler for the auxiliary generator that powered the turret, located to the left of and above the main muffler. Below the muffler are the mountings for the idlers. *Massimo Foti*

The hubcaps on the road wheels of the Bovington Pz.Kpfw. IV Ausf. D are the type that made their debut on the Ausf. E, with six bolts around the perimeter. On the supplemental armor on the side of the superstructure, a vertical joint is to the rear of the steering-brake exhaust outlet. On the fender is the spare road wheel rack. *Massimo Foti*

CHAPTER 5
Panzer IV Ausf. E

Initially, it was planned that 223 Ausf. E tanks be produced as the 5.Serie/BW, however the ordering of forty-eight Ausf. D for the SS as the 5.Serie forced the redesignation of the Ausf. E as the 6.Serie/BW. A contract was issued in July 1939 for production of these vehicles, which began in October 1940. In March 1941, just one month before cessation of Ausf. E production, seventeen vehicles were cut from this order, bringing the total to 206.

Because of lessons learned in Poland, it was hoped that these tanks could be equipped with 50 mm armor on the front of the superstructure, but this was not to be. Instead, on July 12, 1940, it was decided that the Ausf. E would continue to use the 30 mm face plate augmented by a 30 mm supplemental armor plate, as had been the case for the bulk of the Ausf. D production. The superstructure front continued to be set back in front of the radio operator's position as well.

The turret top changed with the introduction of the Ausf. E. The commander's cupola used was that of the Panzer III Ausf. G with five vision ports. The armored plate forming the rear of the turret was no longer bulged to accommodate the cupola, but rather rose to a point just behind the cupola.

The turret also had only one signal opening, on the left side of the roof forward of the cupola, unlike previous models which had a signal opening on either side forward of the cupola. Because of complaints about excess gas buildup when firing the main gun, a ventilator was added to the roof of the turret, well forward and to the right of the cupola.

New versions of the drive sprockets and cast steel road wheel hubs were introduced with the Ausf. E production. Internally, a new type of auxiliary generator began to be used, this powered by an Auto Union model ZW500 2-cylinder engine, rather than the previously used PZW600 engine furnished in earlier models. As was the case for all Panzer IV, since the Ausf. B, the radio equipment installed was the Fu 5 10-watt transmitter and Fu 2 receiver, with a range of 2.5 to 4 miles, depending on terrain.

Ausf. E, 6.series B.W.	
Make	Krupp-Grusonwerk
Chassis (Fgst) number	80301-80440 80801-81006
Quantity	206
Dimensions	
Length	19' 5.07"
Width	9' 5.39"
Height	8' 9.51"
Wheelbase	8' .85"
Track contact	11' 6.58"
Weight	48,510 pounds
Automotive	
Engine	Maybach HL120TRM
Configuration	V-12, water-cooled
Displacement	11.9 liters
Power output	265 hp @ 2600 rpm
Fuel capacity	124 gallons
Transmission	ZF S.S.G.76
Speeds	6 + reverse
Steering	differential
Track	Kgs 6111/380/120
Links per side	99
Performance	
Crew	5
Max speed	26 mph
Cruising speed	15.5 mph
Cross-country	12.5 mph
Range, on-road	130 miles
Range, cross-country	80 miles
Fording depth	31.5"
Trench crossing	7.5'
Armament	
Main gun	7.5 cm Kw.K. 37 L/24
Range	2,000 meters
Coaxial	7.92 mm MG 34
Elevation	-10 to +20 degrees
Ball mount	7.92 mm MG 34
Ammo, 7.5 cm	80 rounds
Ammo, 7.92 mm	3,150 rounds

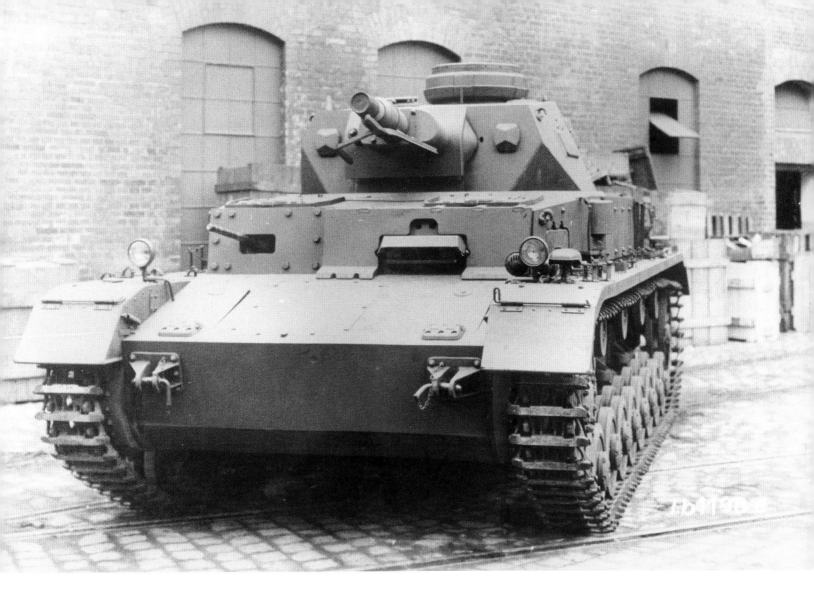

At the rear of the tank an armored box now enclosed the smoke-grenade discharger, located just above the muffler. Beginning in March 1941, a baggage box began to be installed on the rear of the turret. This was also retroactively installed on vehicles previously delivered.

As with the Ausf. D, limited numbers of Ausf. E tanks were equipped with either deep water fording or tropical gear after production. While 206 tanks had been ordered, only 200 were produced as gun tanks. Four Ausf. E chassis were used to produce bridge layers, and the final two, chassis 81005 and 81006, were set aside for running gear experiments.

Krupp-Grusonwerk completed 206 Pz.Kpfw. IV Ausf. Es. Changes from the Ausf. D included but were not restricted to new sprockets without the oblong holes around the perimeter; new hubcaps for the road wheels; strengthened armor designed to be proof against 3.7 cm projectiles; new driver's visor; inclusion of a ventilator fan in the turret roof; a redesigned commander's cupola; and an armored smoke-grenade dispenser. Although the vertical bow armor was increased to 50 mm, the face of the superstructure was left at 30 mm; as availability allowed, 30 mm supplemental armor was installed on the superstructure front, as seen here.
Patton Museum

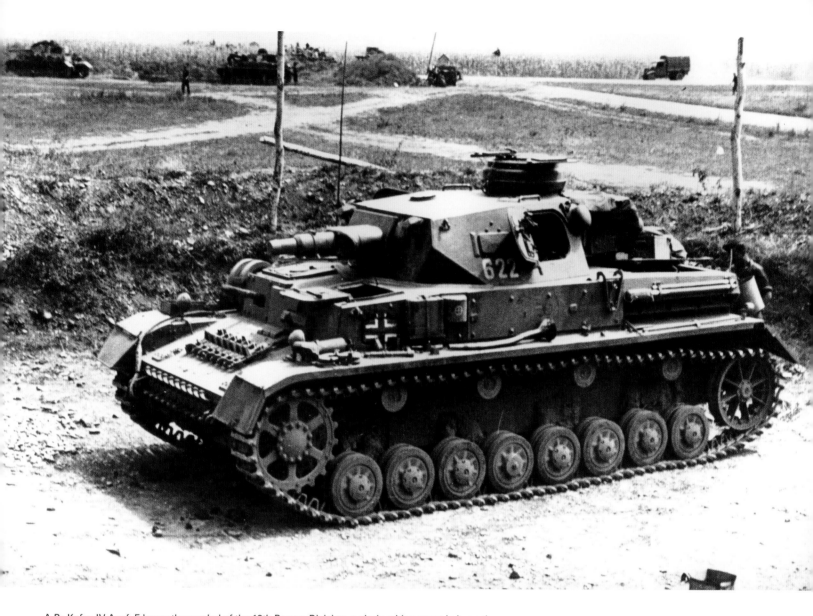

A Pz.Kpfw. IV Ausf. E bears the symbol of the 13th Panzer Division, a circle with a cross in it, on the armored air outlet for the steering brakes on the side of the superstructure. The Pz.Kpfw. IV Ausf. E had basic superstructure side armor of 20 mm, with supplemental 20 mm armor bolted on top of it. This armor was cut out for the driver's side vision port. The vertical side armor of the hull was 20 mm, with a 20 mm supplemental plate over the central part of the side armor. The front end of that supplemental plate is faintly visible below the forward track-support roller. The three bolts above the side vision port of the turret were to hold the interior structure of the vision port. *Patton Museum*

In this series of photographs, a Pz.Kpfw. IV Ausf. E has veered off a narrow wooden bridge, leaving the right suspension and track hanging over the edge. Ever since the introduction of the Pz.Kpfw. IV Ausf. D, these tanks had been equipped with the Kgs 6111/380/120 tracks with the taller guide horns than those on the Kgs 6110/380/120. The underside of the antenna deflector is visible from this angle. *National Archives and Records Administration*

The same tank is seen from a slightly different angle. Jerrycan liquid containers are lined up on the rear of the engine deck, enabling the vehicle to carry, to a certain extent, its own fuel and water during the advance. *National Archives and Records Administration*

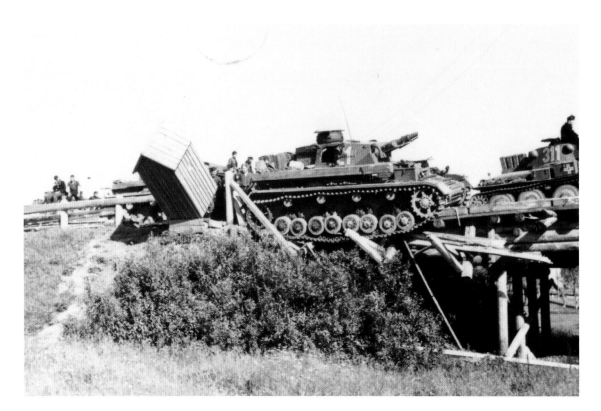

A wider view shows the Pz.Kpfw. IV Ausf. E in its predicament, derailed on a wooden bridge. The Pz.Kpfw. 38(t) to the right has just passed the vehicle. Positioned like this, the Pz.Kpfw. IV Ausf. E would pose an interesting engineering challenge to a recovery crew. *National Archives and Records Administration*

In a final, frontal view of the Pz.Kpfw. IV Ausf. E that has become stuck on a bridge, the "Y" symbol of the 7th Panzer Division is on the front left of the superstructure. A length of spare track is inserted in a holder on the bow, and two additional lengths of spare track are secured to the glacis. Supplemental vertical armor on the front of the driver's compartment is cut out to accommodate the new style of driver's visor, which was hinged on each side and flipped up or down. In the cutout above the visor are the two openings for the driver's binocular periscope. *National Archives and Records Administration*

The turret of a Pz.Kpfw. IV Ausf. E numbered 421 is traversed to the rear. The shutters for the front vision slot on the new-type cupola are open. There were five vision slots and shutter sets, each of which was backed with a glass shield. The shutters were fully adjustable to regulate the amount of exposure of the vision slot. The coaxial 7.92 mm MG 34 has been removed from its mount. Above the muffler to the far right is the armored smoke-grenade dispenser. The rectangular object on the rear of the left fender is a Notek blackout taillight, also referred to as a convoy taillight. *National Archives and Records Administration*

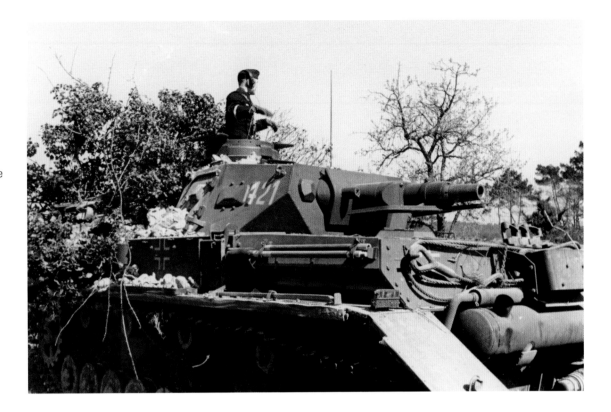

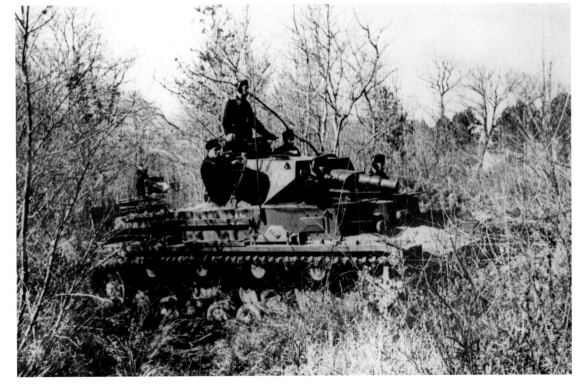

The crewmen of a Pz.Kpfw. IV Ausf. E situated in a brushy area in France in 1941 watch expectantly to the front. The 7.5 cm gun is slightly depressed; this piece had a maximum depression of -10 degrees and a maximum elevation of +20 degrees. A white number 431 is faintly visible on the side of the turret. This is one of the Ausf. E vehicles that was not equipped with supplemental armor on the superstructure. On the roof is the hood of a ventilator fan, which first made its appearance on the Ausf. E. *National Archives and Records Administration*

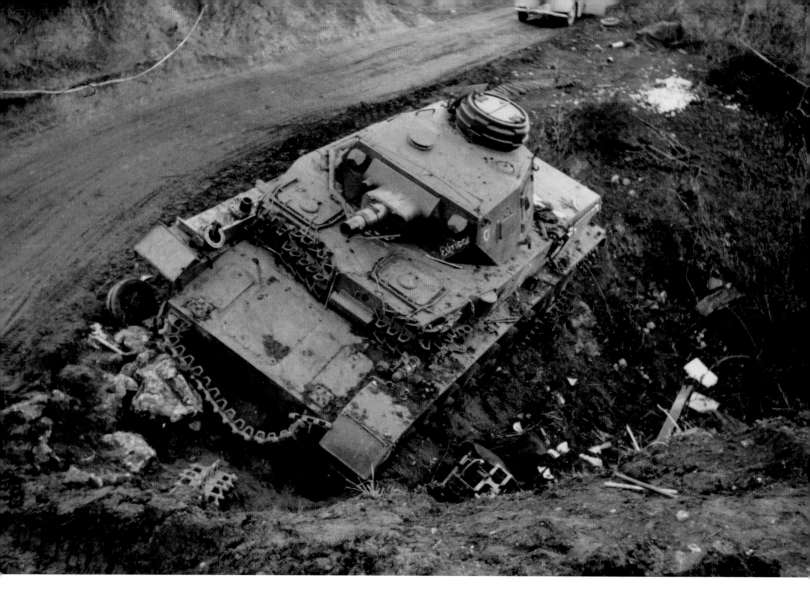

An elevated view of a knocked-out 3. Panzer Regiment, 2. Panzer Division Pz.Kpfw. IV Ausf. E reveals some details of key features of this model. On the roof of the turret is the ventilator hood and the new cupola with its split hatch. The left signal port, to the front left of the cupola, had been retained but the right signal port had been eliminated. This vehicle lacked supplemental armor for the superstructure. A nickname, evidently "Elfrieda," is painted diagonally on the left side of the frontal plate of the turret. *National Archives and Records Administration*

British technicians pore over a Pz. Kpfw. IV Ausf. E captured in North Africa. The number 800 is painted on the turret with white outlining. On the superstructure aft of the radio operator's vision port, the cover of which is missing, is the symbol of the *Afrika Korps*. The dark, horizontal line through the *Balkenkreuz* and to its rear is the original *Dunkelgrau* paint where the radio-antenna guard has been removed. The ball machine gun, the right track, and the forward track-support roller are missing. *Patton Museum*

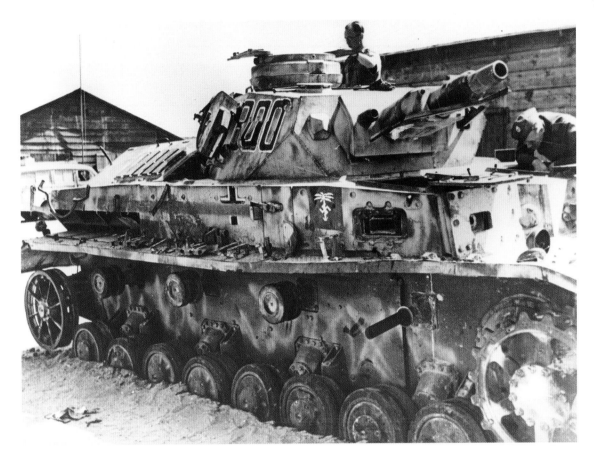

This captured Pz.Kpfw. IV Ausf. E had the supplemental front and side armor on the superstructure. A close-up view is available of the new driver's visor, which operated on pivots on each side, swinging up or down to expose or hide the driver's vision port. A very faint *Afrika Korps* symbol is on the left side of the supplemental armor over the ball machine-gun mount. *Patton Museum*

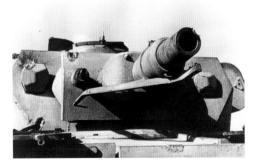

A number of projectile hits have registered on this Pz.Kpfw. IV Ausf. E, including one on the upper left quarter of the muzzle, one on the upper right part of the mantlet above the coaxial machine gun, one on the top of the right front observation port of the turret, and one on the front of the turret below the right observation port. *Patton Museum*

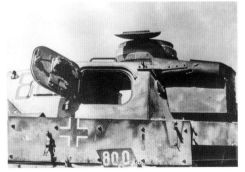

The left side of the turret of the Pz.Kpfw. IV Ausf. E numbered 800 that the British captured in North Africa is shown. The vehicle's tactical number is painted on a rhomboid placard next to the superstructure. A piece of metal strapping served to reinforce the attachment of the stowage bin to the turret. Jutting from the inside of the turret door is the viewing device that held a thick piece of glass to protect the crewmen from splinters. Above the door is a rain guard. *Patton Museum*

CHAPTER 6
Panzer IV Ausf. F

Ausf. F, 7.series B.W.	
Make	Krupp Grusonwerk
Chassis (Fgst) number	82001-82395
Make	Vomag
Chassis (Fgst) number	82501-82565
Make	Nibelungenwerk
Chassis (Fgst) number	82601-82613
Quantity	473

Dimensions	
Length	19' 5.07"
Width	9' 5.39"
Height	8' 9.51"
Wheelbase	8' .85"
Track contact	11' 6.58"
Weight	49,170 pounds
Automotive	
Engine	Maybach HL120TRM
Configuration	V-12, water-cooled
Displacement	11.9 liters
Power output	265 hp @ 2600 rpm
Fuel capacity	124 gallons
Transmission	ZF S.S.G.76
Speeds	6 + reverse
Steering	differential
Track	Kgs 61/400/120
Links per side	99
Performance	
Crew	5
Max speed	26 mph
Cruising speed	15.5 mph
Cross-country	12.5 mph
Range, on-road	130 miles
Range, cross-country	80 miles
Fording depth	31.5"
Trench crossing	7.5'
Armament	
Main gun	7.5 cm Kw.K. 37 L/24
Range	2,000 meters
Coaxial	7.92 mm MG 34
Elevation	-10 to +20 degrees
Ball mount	7.92 mm MG 34
Ammo, 7.5 cm	80 rounds
Ammo, 7.92 mm	3,150 rounds

The initial order for the Panzer IV Ausf. F was for a mere 128 examples, ordered in December 1938. After Germany invaded Poland a greater need for the tank was revealed, and the order was increased to 500 in November 1939. This increase was followed by orders for 100 Panzer IV Ausf. F each placed with two new assembly firms, Vomag and Nibelungenwerk (Steyr). Finally, in January 1941, Krupp was awarded a contract for an additional 300 examples of the type.

The Ausf. F saw the return of the single-plane face of the superstructure front, although the thickness of the armor was increased to 50 mm, and was face-hardened, increasing the level of protection so as to be proof against 37 mm rounds. A ball mount for the MG 34 was incorporated into the superstructure front, directly ahead of the radio operator. At the same time, side armor protection was increased to 30 mm. The driver now had a visor developed for the Sturmgeschütz.

Naturally, thicker armor meant increased weight. In order to maintain off-road mobility in spite of the ever-increasing weight of the Panzer IV, which by this point had climbed almost five tons over the weight of the Ausf. A, the decision was made to utilize larger tracks. The new tracks were 20 mm wider, requiring a change to the drive sprocket. At the same time, the width of the rubber tires on the road wheels was increased from 75 mm to 90 mm.

At the rear of the tank, the muffler was made shorter, and the auxiliary power plant, which previously had exhausted into the main engine muffler, now boasted its own small muffler. The smoke grenade discharger was moved to a position over the small muffler.

Whereas prior models had a single large hatch on either side of the turret, the Ausf. F utilized a pair of smaller hatches on each side. These side hatches were originally designed for use on the Panzer III turret.

Despite the adoption of 50 mm frontal armor, beginning in February 1942, 20 mm supplemental armor began to be mounted on the hull front and turret face, in deference to a request from Hitler himself. At about the same time, installation of the smoke grenade dischargers was discontinued, owing to reports from the field that they were inadequate.

When the decision was made to begin arming the Panzer IV with the long-barreled 75 mm KwK40 (L/43) instead of the short 75 mm KwK L/24 starting on March 1, 1942, production of the Ausf. F was cut short. This meant that of the 1,000 Ausf. F ordered, Krupp produced 395, Vomag sixty-five, and Nibelungenwerk (Steyr) only thirteen.

The Pz.Kpfw. IV Ausf. F featured thicker armor, with integral or organic 50 mm face-hardened plates on the fronts of the superstructure and the turret replacing the 30 mm + 30 mm superstructure armor and the 30 mm frontal armor of the turret of the Ausf. E. The superstructure front was flat, not stepped. The side armor of the hull and superstructure was upgraded to 30 mm face-hardened armor, and the mantlet was 50 mm thick. The D-shaped turret doors were replaced by two-panel doors forming a rectangle. The main armament was the 7.5 cm KwK L/24; when the Pz.Kpfw. IV Ausf. F2 (soon to be redesignated the Ausf. G) was developed, featuring the 7.5 cm KwK 40 L/43, the Ausf. F was redesignated the Ausf. F1. *Bundesarchiv 146-1979Anh.-001-10*

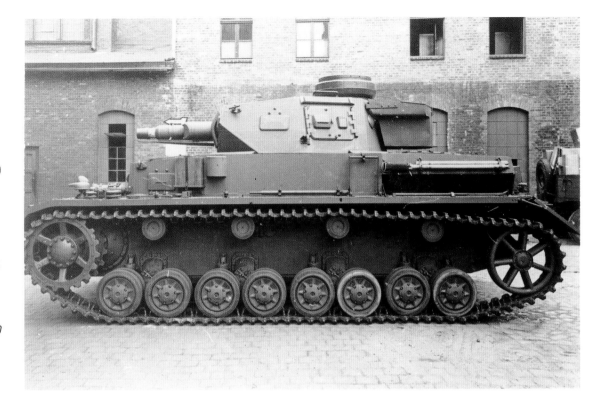

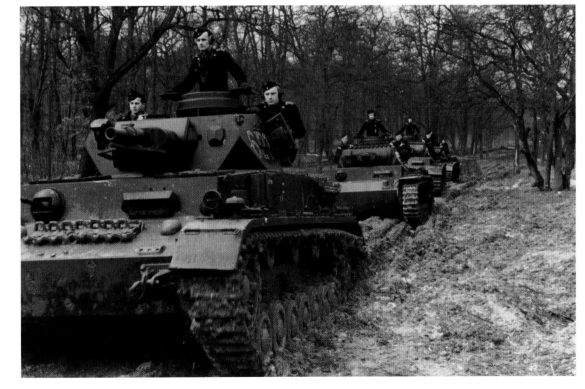

A Panzer IV Ausf. F leads a column along a muddy trail through the woods. The Ausf. F introduced the use of the *Fahrersehklappe* 50 vision port, originally developed for the StuG. Above the vision port are two holes in the 50 mm-thick superstructure faceplate. These are the driver's optics, which provide a 65-degree field of vision. *National Archives and Records Administration*

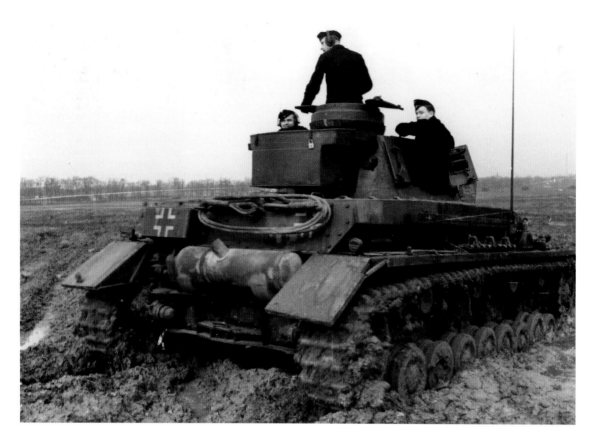

A Pz.Kpfw. IV Ausf. F negotiates very muddy terrain on training ground in France. The Ausf. F featured widened road wheels and wider tracks, the Kgs 61/400/120 type, to better support the heavier weight of this vehicle. Introduced with the Ausf. F was a revised exhaust for the auxiliary generator, including a box-shaped muffler partially visible to the left of the main muffler, also of a new design. Above the auxiliary generator muffler was the armored cover of the smoke-grenade dispenser. *National Archives and Records Administration*

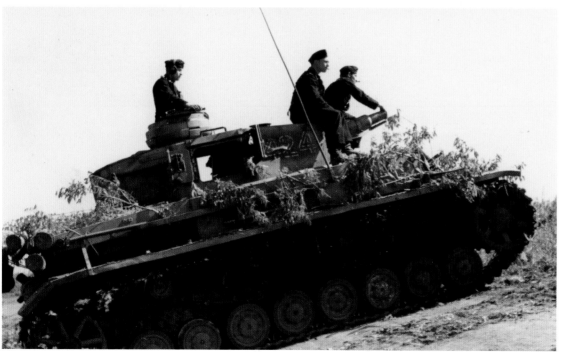

Two crewmen take a cigarette break to the front of the commander of a Pz.Kpfw. IV Ausf. F. Tree branches have been arranged on the tank for camouflage. On the rear panel of the turret door is a pistol port. Although the front panel is open at such an angle that details on it are difficult to discern, a vision slit backed by a thick glass shield is mounted on that panel. *National Archives and Records Administration*

A Pz.Kpfw. IV Ausf. F is viewed from above at an assembly where a military band is playing. The ventilation grilles on the engine-access doors on the rear deck were installed on some but not all Ausf. Fs. The polished-metal connectors on the multipart bore-cleaning staff stored on the left side of the engine compartment are evident. The crewman in the left turret door has his left hand on one of two spare road wheel assemblies stored in a holder on the left fender; this type of holder was introduced to production in May 1942. Under his elbow is the sole remaining signal port on the turret roof. *National Archives and Records Administration*

A Pz.Kpfw. IV Ausf. F and other vehicles are assembled at a port, apparently in North Africa or the Mediterranean. A clear view is available of the new-style muffler, the auxiliary-generator muffler to the left of it, and the armored shield for the smoke-grenade launcher next to the folded-up left rear mudguard. Also new for the Ausf. F were the idlers, fashioned from welded tubular steel. *Patton Museum*

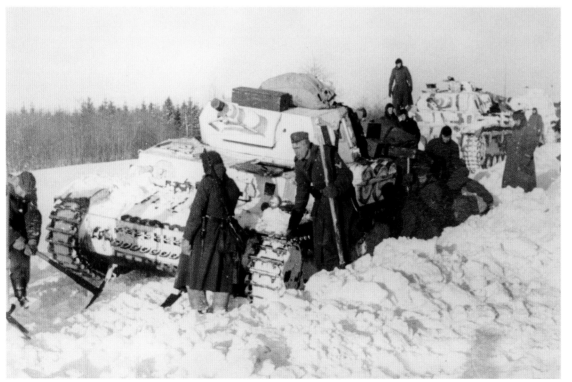

Soldiers with picks and shovels dig a pathway through the snow to make the advance easier for several 5th Panzer Division Pz. Kpfw. IV Ausf. Fs on the Eastern Front. The nearest vehicle has a thoroughly applied and apparently recent camouflage covering of whitewash, while the second vehicle has whitewash but with some dark areas of the original paint exposed, probably intentionally for a two-tone camouflage effect. Three road wheel assemblies are stored on the left fender. *National Archives and Records Administration*

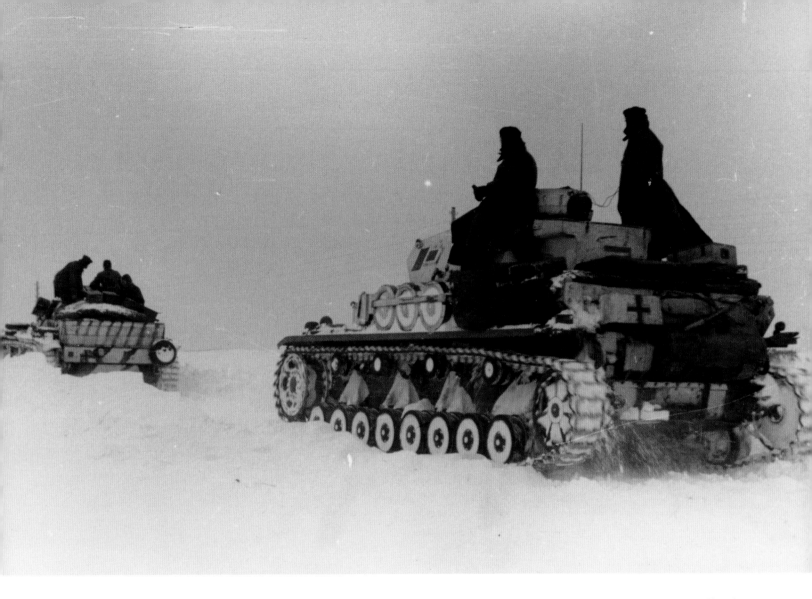

Two Pz.Kpfw. IV Ausf. Fs from the same 5th Panzer Division formation depicted in the preceding photo make their way across a snowy wasteland on the Eastern Front. Interrupting the whitewash camouflage of the front vehicle are dark stripes where the wash was not applied to the original *Dunkelgrau* paint, and care was taken to apply the whitewash around the *Balkenkreuz* on the rear of the hull. This tank has a wooden storage bin on the rear of the engine deck. The vehicle to the rear has an uninterrupted whitewash scheme, and two dark-colored rectangles are on the turret, likely for preserving a unit symbol and vehicle number, based on photographic evidence in other photos of 5th Panzer Division Pz.Kpfw. IV Ausf. Fs. *National Archives and Records Administration*

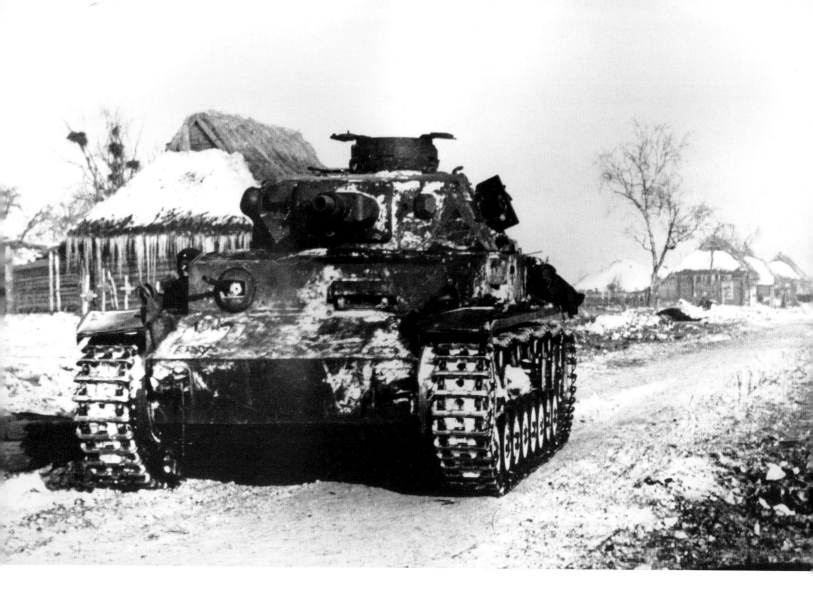

Whitewash camouflage was water-based and tended to dissolve under the elements as the winter progressed. Such was the case with this Pz.Kpfw. IV Ausf. F rolling through a settlement on the Eastern Front. The Ausf. F was the first model of the Pz.Kpfw. IV to have armored air scoops on the steering-brake access hatches. The one on the right hatch of this tank is visible to the front of the ball machine-gun mount. The ball mount was the *Kugelblende* 50 model, and the driver's visor was the *Fahrersehklappe* 50, adapted from the Sturmgeschütz driver's visor. *Patton Museum*

British troops pose for their photograph on a destroyed Pz.Kpfw. IV Ausf. F in North Africa. To the right, leaning on the hull, is the upended superstructure, with the driver's visor and the ball machine-gun mount visible in the foreground. *National Archives and Records Administration*

CHAPTER 7
Panzer IV Ausf. F2/G

Ausf. F2/G, 8.series B.W.	
Make	Krupp Grusonwerk
Chassis (Fgst) number	82396-82500 82701-83000 83201-83400 83651-83950
Make	Vomag
Chassis (Fgst) number	82566-82600 83001-83100 83401-83550 83951-84100

Make	Nibelungenwerk
Chassis (Fgst) number	82614-82700 83100-83200 83551-83650 84101-84400
Quantity	1,927
Dimensions	
Length	21' 9"
Width	9' 5.39"
Height	8' 9.51"
Wheelbase	8' .85"
Track contact	11' 6.58"
Weight	52,038 pounds
Automotive	
Engine	Maybach HL120TRM
Configuration	V-12, water-cooled
Displacement	11.9 liters
Power output	265 hp @ 2600 rpm
Fuel capacity	124 gallons
Transmission	ZF S.S.G.76
Speeds	6 + reverse
Steering	differential
Track	Kgs 61/400/120
Links per side	99
Performance	
Crew	5
Max speed	26 mph
Cruising speed	15.5 mph
Cross-country	12.5 mph
Range, on-road	130 miles
Range, cross-country	80 miles
Fording depth	31.5"
Trench crossing	7.5'
Armament	
Main gun	7.5 cm Kw.K. 40 L/43
Range, direct fire	1,800 meters
Coaxial	7.92 mm MG 34
Elevation	-10 to +20 degrees
Ball mount	7.92 mm MG 34
Ammo, 7.5 cm	87 rounds
Ammo, 7.92 mm	3,150 rounds

As potential adversaries increased the armor protection of their vehicles, German leadership felt obliged to equip their tanks with more powerful weapons. In the case of the Panzer IV, the initial concept, directed by Hitler on February 19, 1941, was to install a 50 mm gun. An initial installation was made on Ausf. D chassis 80668. However, within weeks of the decision to arm the Panzer IV with a 50 mm gun, the decision had also been made to create a trial installation of a new 75 mm gun.

Multiple versions of the 75 mm gun were tried before settling initially on the 7.5 cm KwK 40 L/43. As mentioned previously, this gun began to be used in Panzer IV production in March 1942. The vehicles so equipped were known variously as 7./BW-Umbau, Panzer IV Ausf. F-Umbau, Panzer IV Ausf. F2, and a host of other designations until the matter was settled once and for all on July 1, 1942, that the designation was to be 8./BW Panzer IV Ausf. G.

The remaining 527 previously-contracted Ausf. F tanks were completed as Ausf. G models. Further additional contracts were also issued for 1,400 more examples of the Ausf. G.

The earliest of the Ausf. G vehicles differed from the immediately preceding Ausf. F vehicles only in areas directly related to the main gun, including gun mantlet, internal travel lock, gun sight, and of course ammunition stowage racks. The KwK 40 ammunition, incidentally, differed from both the earlier 75 mm ammunition and PaK 40 ammunition, even though the new tank gun was derived from the famed antitank weapon.

The KwK 40 L/43 did not remain the weapon of choice for the Ausf. G for the entire production run, giving way in April 1943 to the even longer KwK 40 L/48. The latter gun was easier to manufacturer, owing to its consistent 7-degree rifling twist, as opposed to the L/43 twist which began at 6-degrees and transitioned to 9-degrees.

Production of the Ausf. G was completed in June 1943. In addition to the change in the main gun during the course of production, the Ausf. G lost its turret side and right front visors in April 1942, incorporated a running board-mounted rack for spare road wheels and a glacis rack for spare track links beginning in June 1942, and both the hull and superstructure fronts were augmented with 30 mm armor plate on some tanks beginning in May 1942.

In an effort to improve the armament of the Pz.Kpfw. IV, whose 7.5 cm KwK L/24 was effective against troop concentrations, softskin vehicles, and lightly armored vehicles, the Germans experimented with several Pz.Kpfw. IVs with more potent guns. This Pz.Kpfw. IV Ausf. F has been fitted with a wooden dummy of a 5 cm KwK L/60 to test the feasibility of that gun in the Pz.Kpfw. IV turret. Ultimately, an even more powerful 7.5 cm gun would be the final choice. *Patton Museum*

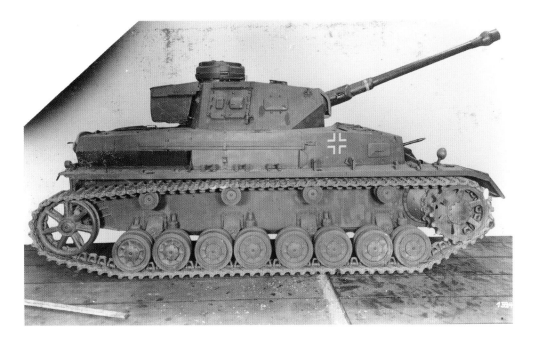

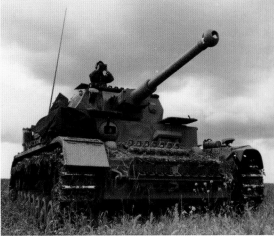

Beginning in February 1943, a new commander's cupola was introduced which had a single-piece hatch, rather than the split hatch used previously. Also, from February through May 1943, a three-barrel smoke grenade launcher was mounted near the upper front of the right and left turret sides. In April 1943, armor plate skirts, or Schürzen, began to be installed on the hull sides and turret. This increased protection from antitank rifles.

Orders were issued in July 1942, stipulating that when older tanks in the Ausf. D through Ausf. F came in for depot level overhaul they would be rearmed with the 75 mm KwK 40, as well as receiving chassis updates.

The Pz.Kpfw. IV Ausf. F2 basically was the Ausf. F (now redesignated the F1) with the 7.5 cm KwK L/24 replaced by the longer-barreled 7.5 cm KwK 40 L/43, which had a much more potent punch, particularly against armor. The Ausf. F2 also featured revised ammunition storage with a capacity of eighty-seven 7.5 cm rounds; an auxiliary traversing mechanism and modified gun mount and mantlet; and a new gun sight, the T.Z.F.5f. There also were numerous minor revisions to the Ausf. F2. On this example of an Ausf. F2, the main gun featured a single-baffle, ball-shaped muzzle brake. *National Archives and Records Administration*

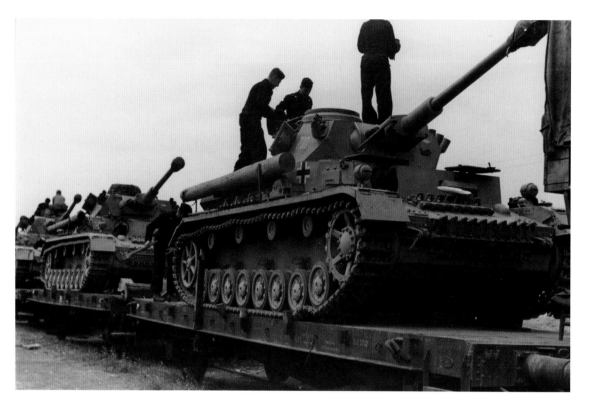

The Pz.Kpfw. IV Ausf. F2 was a short-lived designation in effect for only three months, after which the model designation was changed to Ausf. G. Shown here are several Pz.Kpfw. IV Ausf. Gs loaded on railroad flatcars for transport. Although muzzle covers are present on the 7.5 cm guns, it can be discerned that the muzzle brakes were the two-chamber type introduced in August 1942. Holders for unditching beams are installed as a modification on the right fenders. On the closest tank above the ball mount for the bow machine gun, the chassis number is faintly visible: it is in the 830xx range. The chassis numbers for the Ausf. F2/G ran from 82394 to 84400. The type of antenna deflector seen here was introduced in June 1942. *National Archives and Records Administration*

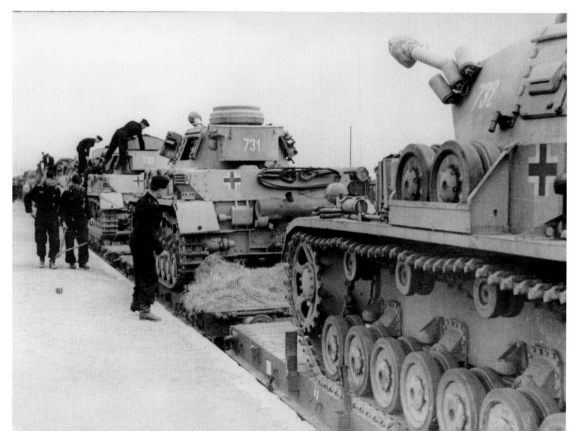

In a scene reminiscent of the preceding photo, and possibly showing vehicles of the same company, Pz.Kpfw. IV Ausf. Gs are loaded on flatcars in Greece or the Balkans. They bear tactical numbers, front to rear, 732, 731, and 733. Number 731 bears the same type of unditching beam and holders on the right fender as the tank in the preceding photo. This type of smoke-grenade launchers on the sides of the turret was introduced to production in February 1943. *National Archives and Records Administration*

Crewmen scramble aboard a Pz. Kpfw. IV Ausf. G in Yugoslavia in early 1944. Beginning in April 1943, armored skirts were installed on Pz.Kpfw. IV Ausf. Gs at the factory. These skirts included one set partially enclosing the turret, with an opening at front for the 7.5 cm gun, and a series of armor plates along the sides of the hull and the superstructure. The purpose of the plates was to defeat antitank rifle rounds before they struck the hull or turret sides. On this tank, the turret skirt is present but the side skirts for the hull and superstructure are not.
Patton Museum

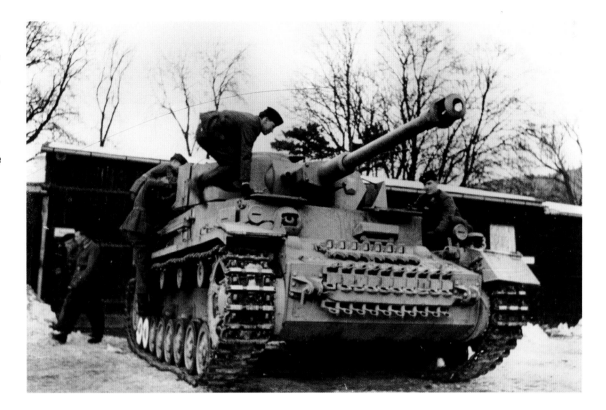

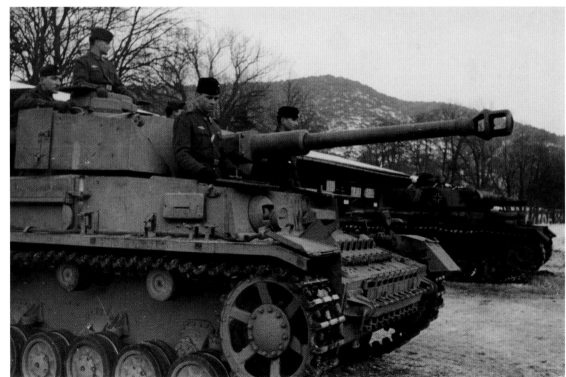

The same Pz.Kpfw. IV Ausf. G featured in the above photo is viewed from another perspective. The crewmen are not wearing German uniforms. The turret skirts had two-panel doors on each side to allow access to the side doors of the turret. In the background is a Pz.Kpfw. III Ausf. N with a multicolor camouflage scheme and a white *Balkenkreuz* on the turret skirt. *National Archives and Records Administration*

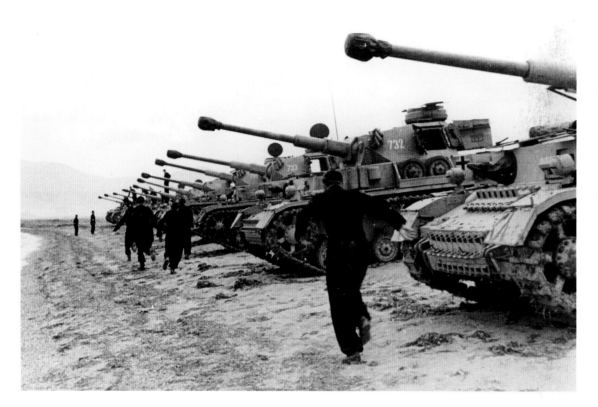

Crewmen dressed in black panzer uniforms hustle to mount their Pz.Kpfw. IV Ausf. Gs along a seashore in Greece or the Balkans. The second vehicle has the split hatch on the cupola that originally was installed on the Ausf. Gs. The third and fourth vehicles have the single-piece, round hatch for the cupola, which was introduced to production in February 1943. A dark-colored dust cover is over the ball mount and the MG 34 on the nearest tank. *National Archives and Records Administration*

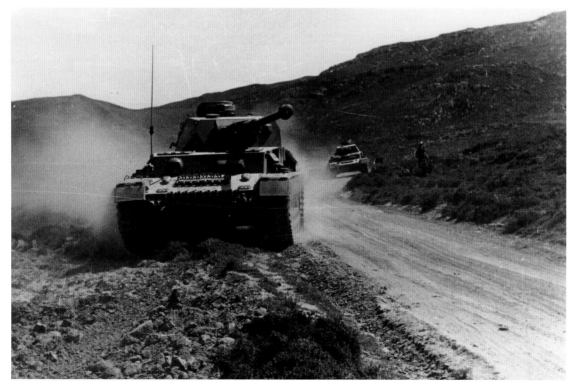

Two Pz.Kpfw. IV Ausf. Gs maneuver along a dusty road in hilly country. Both tanks lack armored skirts or turret-mounted smoke-grenade launchers. The nearer tank has the so-called acorn-shaped muzzle brake with two baffles, which was introduced to production in September 1942. For the Pz.Kpfw. IV Ausf. G, the right multifaceted observation port on the front of the turret was omitted, but the left port remained. *National Archives and Records Administration*

Infantrymen in reversible winter parkas and overalls have boarded a Pz.Kpfw. IV Ausf. G of the 4th Panzer Division at a site in Russia on March 21, 1944. On the armor skirt of the turret is the tactical number 135, and the symbol of the 4th Panzer Division, a broken cross inside a circle with crossed swords below it, all of which is within a shield. The name "Hedwig" is painted on the driver's visor. Spare track sections have been generously mounted on the turret roof, the superstructure, and the glacis. The front fender shows the rigors of use, with buckling damage evident. *National Archives and Records Administration*

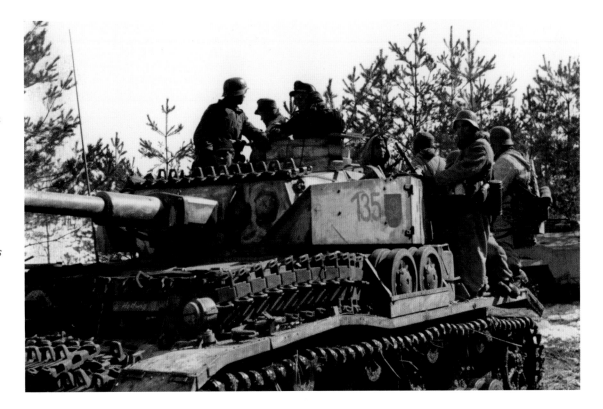

The Pz.Kpfw. IV in the foreground of this view of a motorized column is an Ausf. G, as indicated by the welded supplemental armor on the front of the superstructure, with the cutout for the driver's binocular periscope above the driver's visor. This vehicle has the early cupola with a split hatch. The armor skirts on the sides of the vehicle are the early type whereby the skirts had small cutouts where they rested on their support brackets. *National Archives and Records Administration*

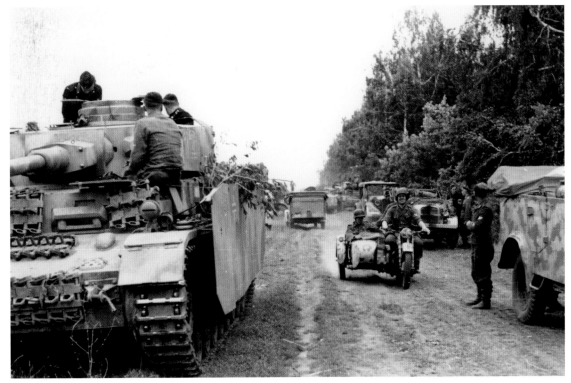

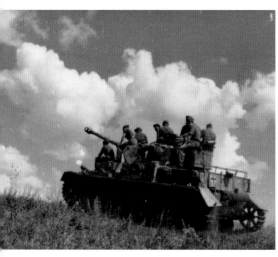

Additional personnel as well as the crewmen of a Pz.Kpfw. IV Ausf. G are taking advantage of the sunny weather as they advance over a grassy knoll. This is an early Ausf. G with the split-hatch cupola and no grenade launchers on the turret. A single road wheel assembly is in the two-wheel rack on the left fender. Toward the front of that fender is a Bosch headlight. A rack has been mounted on the rear of the engine deck to help hold baggage in place. On the stowage box on the turret is the tactical number 313. *National Archives and Records Administration*

A Pz.Kpfw. IV Ausf. F2 passes German officers on a street in a French city. The 7.5 cm gun is equipped with the early-style ball-shaped muzzle brake with a single baffle. The tactical number 216 is painted in outline in white on the turret. Two spare road wheel assemblies are secured to the side of the superstructure without a separate rack. The cupola is the split-hatch type installed on the Ausf. Gs until February 1943. *National Archives and Records Administration*

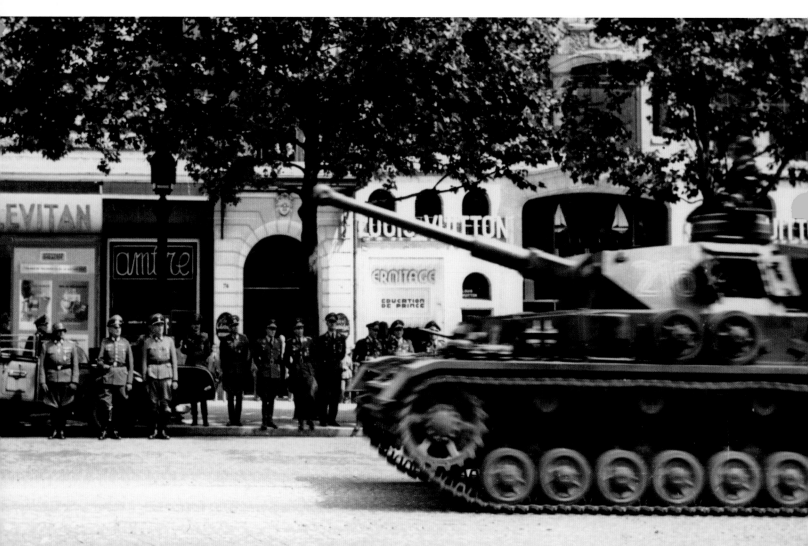

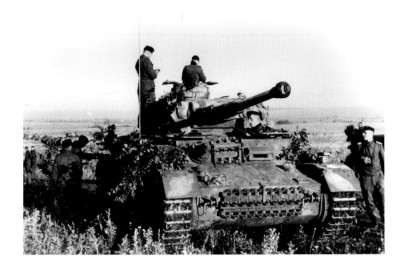

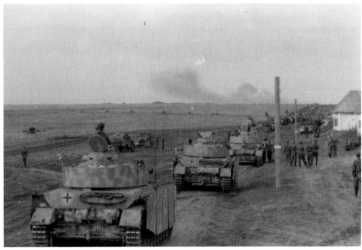

The crew of a Pz.Kpfw. IV Ausf. F2 assigned to Panzer Grenadier Division "Grossdeutschland" takes stock during a break somewhere on the Eastern Front during the summer of 1942. Features worthy of notice include the multicolor camouflage scheme, the ball-shaped muzzle brake, the split hatch on the cupola, the Notek blackout headlight on the left fender, and the presence of an observation port on the right side of the front of the turret: a feature that was phased out of Ausf. G production between April and October 1942. *Patton Museum*

An armored column in motion on the Eastern Front includes several Pz.Kpfw. IVs in the foreground. The nearest tank, an Ausf. G, has the single-piece hatch for the cupola and the early-type armored skirts with cutouts for attaching them to their brackets. The radio antenna is on the right side of the superstructure. Starting in May 1943, the radio antenna was moved from that location to the left rear of the tank. A German flag is on the turret storage bin as an identification aid for friendly fighter and fighter-bomber pilots. *National Archives and Records Administration*

A crewman with binoculars is positioned in the right turret door of a Pz.Kpfw. IV Ausf. G in Tunisia. Above him is a split-hatch cupola. Hanging from the hook at the front of the side of the turret is a *Stahlhelm* (steel helmet). On the radio-antenna holder above the fender is a noticeable horizontal seam: these guards were fabricated from wood with metal brackets. The early-type "acorn" two-baffle muzzle brake is present on the 7.5 cm gun. *Patton Museum*

In a dense thicket, a crewman cleans the bore of the 7.5 cm gun of a Pz.Kpfw. IV Ausf. G. The gun has been traversed and depressed for ease of swabbing the bore. Eight kill rings are painted on the 7.5 cm gun barrel. This vehicle has the split hatch on the cupola and the rack for spare road wheels on the left fender. The shutters of the front vision slot on the cupola are open. *National Archives and Records Administration*

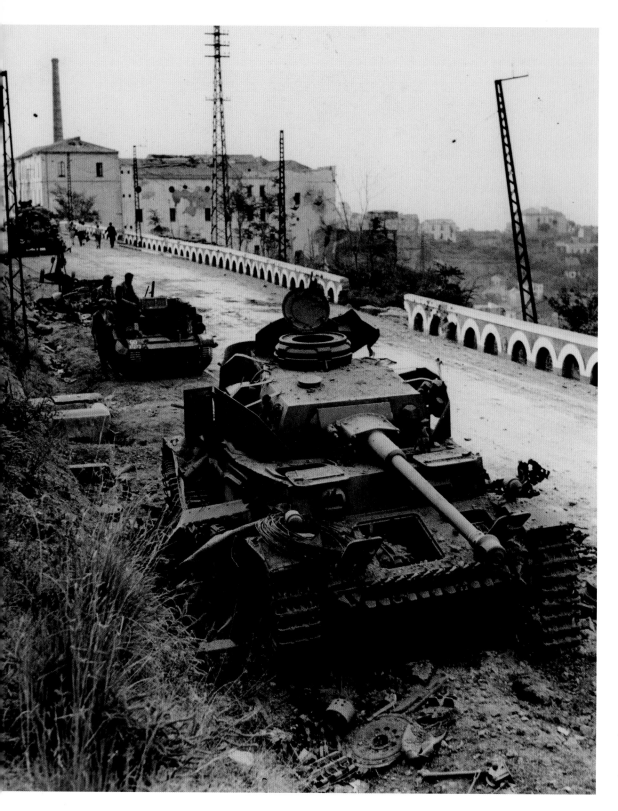

The original caption of this photograph of a knocked-out Pz. Kpfw. IV Ausf. G reads only, "German Mark IV tank destroyed by our accurate mortar fire." The scene seems to be in a British sector in the Mediterranean Theater, as a Universal Carrier is directly behind the tank. The differential cover on the glacis was blown off, and the two steering-brake access doors were blown open by the blast. On the turret are the three-tube smoke-grenade launchers that were installed on Ausf. Gs at the factory from February to May 1943. The signal flap found to the left front of the cupola on the turret roof on early Ausf. Gs was discontinued in March 1943 and is not present on this example. *National Archives and Records Administration*

The Deutsches Panzermuseum in Münster, Germany, preserves this Pz.Kpf. IV Ausf. G, chassis number 83072, built in September 1942 by Vomag. The nickname "Friedericke" is painted on the sleeve at the front of the mantlet of the 7.5 cm gun. The palm-tree and swastika insignia of the *Deutsches Afrika Korps* is on the front of the superstructure, along with the divisional insignia for the 15th Panzer Division. *Massimo Foti*

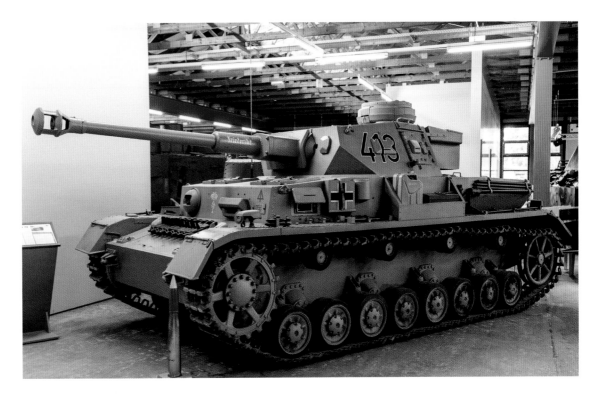

Details of the glacis and the front of the superstructure of the Pz.Kpfw. IV Ausf. G include the driver's visor, the ball mount for the bow machine gun, and a section of spare track, secured by track pins to six holders welded to the glacis. Air scoops are welded to the access doors for the steering brakes. *Massimo Foti*

The driver's and the radio-operator's hatch doors are protected on the fronts and the sides by splashguards screwed to the superstructure roof. Both doors have round observation flaps; this feature was discontinued on the Ausf. G in September 1942. Above the driver's front visor are the apertures for his periscope. *Massimo Foti*

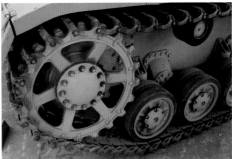

Twelve hex nuts secured with cotter pins secure the hubcap of the sprocket. Casting numbers are visible on the top of the first bogie bracket. A red grease fitting is in the recess at the center of each road-wheel hubcap. Details of the tracks are visible, including the hollowed-out guide horns. *Massimo Foti*

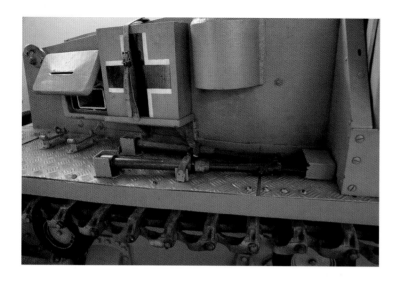

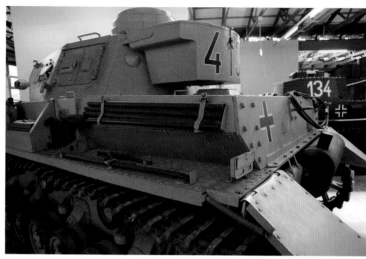

A set of wire cutters is in a holder on the left fender, which features a reproduction non-slip texture. Above the cutters are the driver's side vision port, in the open position; a wooden jack block in its holder; and, welded to the superstructure, the semi-cylindrical-shaped armored guard for the exhaust port for the steering brakes. *Massimo Foti*

A Notek taillight is on the rear of the left fender. In holders to the front of the taillight are a crowbar and a track tool; this would not normally be in this position, since it would interfere with the opening and closing of the air-inlet doors (missing here). A coil spring is fitted to the rear mudguard to hold it both in the down and the raised positions. Details of the turret stowage bin and the rear of the hull are also visible. *Massimo Foti*

One of the track-support rollers, also called track-return rollers, on the left side of the Pz.Kpfw. IV Ausf. G is viewed close-up. There were four sets of these rollers on each side of the vehicle, with two wheels each. To the right of the roller is one of two small, hinged armored flaps that were on the left side of the hull only. *Massimo Foti*

There was a bump-stop to the front of each bogie bracket, to limit the travel of the bogie wheels, and from the Pz.Kpfw. IV Ausf. D on there also was a bump-stop to the rear of each rear bogie bracket. Both bump stops are visible adjacent to the left-rear bogie bracket. *Massimo Foti*

The Pz.Kpfw. IV Ausf. G was powered by the Maybach HL 120 TRM engine. This model of engine was introduced to the Pz.Kpfw. IV during Ausf. C production. The HL 120 TRM was a V-12 gasoline engine rated at 265 horsepower at 2,600 RPM. This display example has been partially cut away to show its inner workings. *Massimo Foti*

The muffler on this Pz.Kpfw. IV Ausf. G appears to be a replacement or modified version, as the real thing had two metal retainer straps, and the exhaust outlet was slanted and was more to the right, as well as lacking a flap. The two curved support cradles under the muffler are correct. A round access flap is above the muffler. *Massimo Foti*

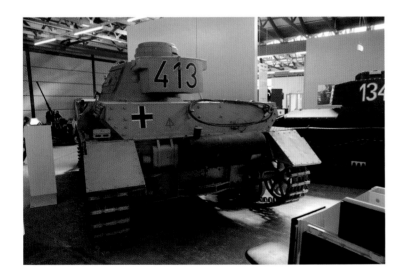

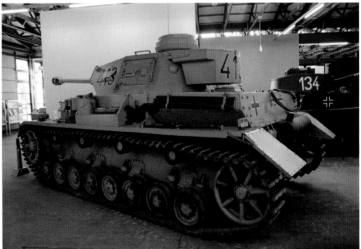

The rear of the Pz.Kpfw. IV Ausf. G at Münster is in view. The muffler has an overall brownish rusty look. To the left of the muffler is the small muffler for the auxiliary generator, secured in place by two metal straps. At the center of the hull below the muffler is the tow fitting. *Massimo Foti*

On the Pz.Kpfw. IV Ausf. F at Münster a nonstandard steel mesh panel has been installed over the louvered air vent on the side of the engine compartment, and the vent doors are missing. A steel strip has been welded to the turret, which supports the stowage bin, and the pistol port below that strip. *Massimo Foti*

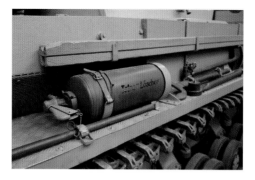

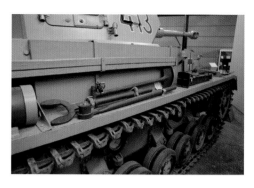

A bracket for securing a track-tensioning tool is welded to the right rear of the engine compartment. The bracket is hinged at the bottom and secured at the top by a nut with a single wing. The location of tools and on-vehicle equipment varied even within a given model of Pz.Kpfw. IV. *Massimo Foti*

A Tetra-Löscher fire extinguisher is in a holder on the right fender. Above the fire extinguisher is the antenna holder, fabricated from wood and mounted on metal brackets bolted to the armor. Farther forward are an open-ended wrench and a closed wrench for adjusting the idlers. *Massimo Foti*

Further details of the antenna holder are available in this photo of the right side of the Pz.Kpfw. IV Ausf. G at Münster. Below it are a shovel and two wrenches. Farther forward on the right fender is the jack. The fixed radio-antenna mount above the jack apparently is a nonstandard postwar addition; the tools are similarly non-original. *Massimo Foti*

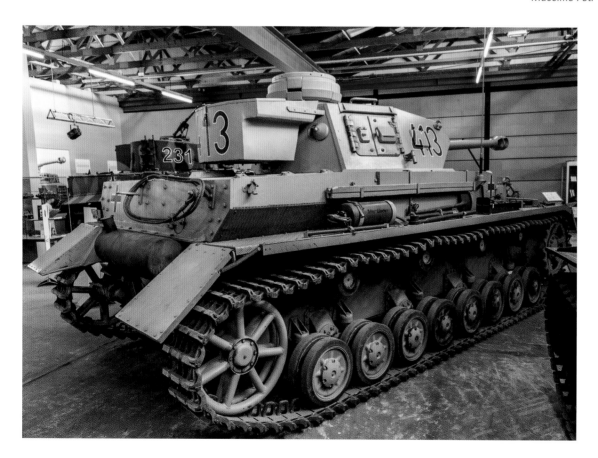

The right side and the rear of the Münster Pz.Kpfw. IV Ausf. G are displayed. The right rear pistol port, under the ledge of the turret stowage bin, has been swiveled to the open position, revealing the oblong slot behind it. The object on the side of the turret to the lower front of the hatch doors is the latch for the front door. *Massimo Foti*

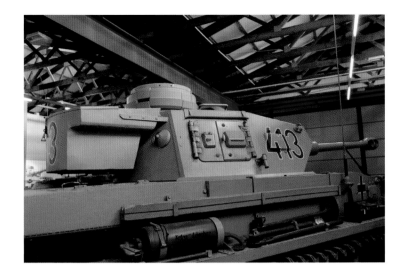

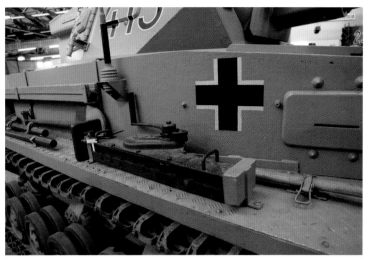

The rear vision port of the Pz.Kpfw. IV Ausf. G cupola is open. This was effected by slightly raising the upper armored shutter of the port and slightly lowering the lower shutter. A rain guard or rain gutter is attached to the turret above the side doors, the front and rear ends flared downward to allow water to escape. *Massimo Foti*

The jack and its storage brackets on the right fender are the focus of this photo. The jack was normally stowed upright, instead of on its side as seen here. The inappropriate antenna mount is to the left of center. To the far right, the four conical-head bolts above and below the radio operator's side vision port secured an inner structure for the port, including a thick piece of ballistic glass. *Massimo Foti*

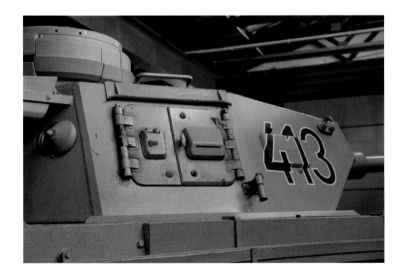

Features on the right side of the turret are shown from a closer perspective. The small, square object on the rear door is a pistol port. On the front door are an oblong handle and a plate with a vision slit. The vision ports on the forward part of the turret sides were progressively discontinued during 1942. *Massimo Foti*

The front right of the turret and 7.5 cm gun mount are depicted, including the multi-faceted observation port on the front right side of the turret, which matched a vision port on the opposite side of the turret. The machine-gun barrel in the coaxial mount is situated much too far forward for accuracy. *Massimo Foti*

CHAPTER 8
Panzer IV Ausf. H

Ausf. H, 9.series B.W.	
Make	Krupp Grusonwerk
Chassis (Fgst) number	84401-84791
Make	Vomag
Chassis (Fgst) number	84901-85350 86151-86393
Make	Nibelungenwerk
Chassis (Fgst) number	85351-85750 86601-87100 89101-89530
Quantity	about 2,325

Dimensions	
Length	23'.377"
Width	9' 5.39"
Height	8' 9.51"
Wheelbase	8' .85"
Track contact	11' 6.58"
Weight	55,125 pounds
Automotive	
Engine	Maybach HL120TRM
Configuration	V-12, water-cooled
Displacement	11.9 liters
Power output	265 hp @ 2600 rpm
Fuel capacity	124 gallons
Transmission	ZF S.S.G.76
Speeds	6 + reverse
Steering	differential
Track	Kgs 61/400/120
Links per side	99
Performance	
Crew	5
Max speed	23.6 mph
Cruising speed	15.5 mph
Cross-country	12.5 mph
Range, on-road	130 miles
Range, cross-country	80 miles
Fording depth	31.5"
Trench crossing	7.5'
Armament	
Main gun	7.5 cm Kw.K. 40 L/43
Range, direct fire	1,800 meters
Coaxial	7.92 mm MG 34
Elevation	-10 to +20 degrees
Ball mount	7.92 mm MG 34
Ammo, 7.5 cm	87 rounds
Ammo, 7.92 mm	3,150 rounds

Internal improvements to the Panzer IV driveline brought about the decision in July 1942, that a new type of Panzer IV, the Ausf. H, would be introduced the following year. However, the new final drives were not ready when Vomag completed Ausf. G production and began Ausf. H production in May 1943; hence the old style final drives continued to be used for the first thirty Ausf. H produced at that facility. By the time that Krupp and Nibelungenwerk began Ausf. H production the following month, the new drives were available, and the tanks were so equipped.

The other significant improvement of the new model over its predecessor was equally well hidden. That was the increase in thickness of turret roof armor, with the front roof plate increasing from 10 mm to 16 mm thick, and the rear armor plate from 10 mm to 25 mm thick. This change was brought about to better protect the tank from low-level fighter attacks, increasingly important owing to the Luftwaffe's continually declining fortunes.

Aerial attacks were by no means the only concern of German tankers, and as early as February 1943, before Ausf. H production had even begun, there were discussions about increasing the thickness of the front plates to 80 mm. These areas had been protected with 14.5 mm on the Ausf. A, and had been periodically increased since. The thicker armor began to be used during the second month of Ausf. H production, June 1943. This meant that the vast majority of the 2,400 or so Ausf. Hs produced featured the heavier armor. The protection was further beefed up by interlocking the front and hull side plates beginning in December 1943.

Despite the ever-increasing armor thickness, the tanks remained vulnerable to magnetic mines. In order to combat this, beginning in September 1943 the tanks left the factories with a coating of *Zimmerit* anti-magnetic paste applied. This paste was intended, both by means of its own thickness as well as its texture, to increase the distance between a magnetic mine and the steel tank, preventing a magnetic mine from being attached. This material was applied by hand and had to set after application. This added days to the manufacturing process—days that Germany could ill afford giving the shifting tide of war.

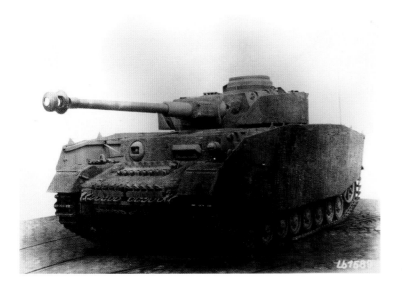

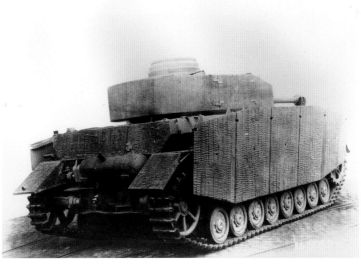

The Pz.Kpfw. IV Ausf. H incorporated a few improvements into the Ausf. G: principally, a more robust final drive featuring higher gear ratios; a new type of cast-steel sprocket with deep indentations in the spokes; and thicker armor on the turret roof. Shown here is Pz.Kpfw. IV Ausf. H chassis number 84599, completed by Krupp in September 1943. It featured an application of *Zimmerit*, including a coating of the anti-magnetic paste on the armored skirts but not on the side of the turret. The skirts were attached to triangular hangers on the skirt brackets. *Patton Museum*

The same Pz.Kpfw. IV Ausf. H, Krupp-built chassis number 84599, is seen from the right rear. No *Zimmerit* was applied to the side of the engine compartment on this vehicle or, presumably, to other vertical portions of the hull or superstructure that were protected by the skirts. The problem was, skirt panels tended to be knocked off or otherwise removed from these vehicles, leaving the hull exposed to magnetic mines. The use of *Zimmerit* on skirts was the exception rather than the rule. The idler is of tubular construction. *Patton Museum*

The need to reduce manufacturing labor, both in terms of time as well as cost, along with material shortages that were the cost of war, also played into the decision to give up the rubber-tired track return rollers that had been part of the Panzer IV from day one. In their place there began to be used all-steel return rollers. Similarly, converting to a cast idler wheel, also in October 1943, reduced manufacturing efforts.

Production of the Panzer IV H was undertaken by Vomag from May 1943, and by Krupp and Nibelungenwerk from June 1943. In December 1943, Krupp was ordered to instead produce StuG IVs, at which time they had built 379 of the 500 Panzer IV Ausf. Hs that the firm had been contracted to produce. These were the last Panzer IVs that Krupp would produce. A portion of Nibelungenwerk's production was also given over to assault gun production beginning in October 1943. That firm appears to have wrapped up Ausf. H production in February 1944, one month after production ceased at Vomag.

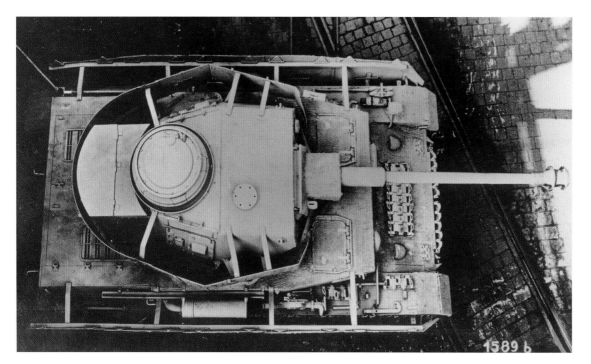

A final shot of Krupp Pz.Kpfw. IV Ausf. H chassis number 84599 shows details of the upper surfaces of the vehicle. On the turret roof to the right of center was the hood for the ventilator. *Zimmerit* is missing from the sides of the turret; it is present on the glacis and the roof over the driver's and radio operator's compartments, but not on the engine deck. *Zimmerit* even has been applied to the enclosure for the 7.5 cm gun's recoil and recuperation assembly to the front of the mantlet. The signal ports in the driver's and the radio operator's hatches from previous models of the Pz.Kpfw. IV now had been discontinued. The cylinder and duct on the middle of the right fender were part of a felt-bellows air filter. *Patton Museum*

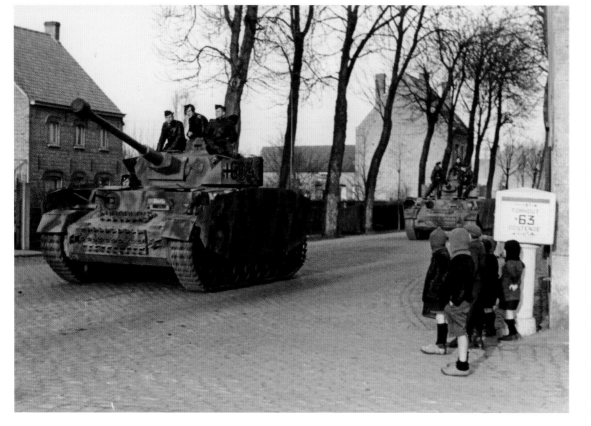

Children watch the advance of Pz.Kpfw. IV Ausf. Hs between Ostend and Torhout, Belgium. The lead tank exhibits the reinforced final-drive assemblies introduced with the Ausf. H tanks; this feature is visible to the right side of the bow. A name, evidently "Derle" or "Dorle," is painted on the driver's visor. The armored skirts are attached to the late-type triangular hangers. The tactical number on the turret, 604, is applied in an irregular manner, with the numerals out of level. This is partially due to the zimmerit that has been applied on the turret skirts. *National Archives and Records Administration*

An Ausf. H leads a column of Pz. Kpfw. IVs. A camouflage pattern has been sprayed over the vehicle's *Dunkelgelb* (dark yellow) base color. Of particular interest is the fact that the camouflage also has been sprayed on the inner surfaces of the armored skirts alongside the hull and the turret. A dark-colored dust cover is over the ball machine-gun mount. *National Archives and Records Administration*

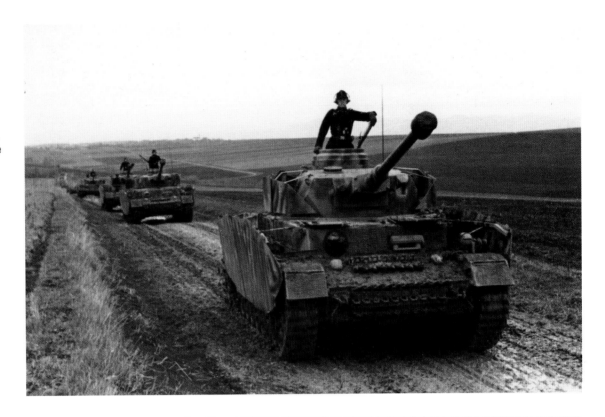

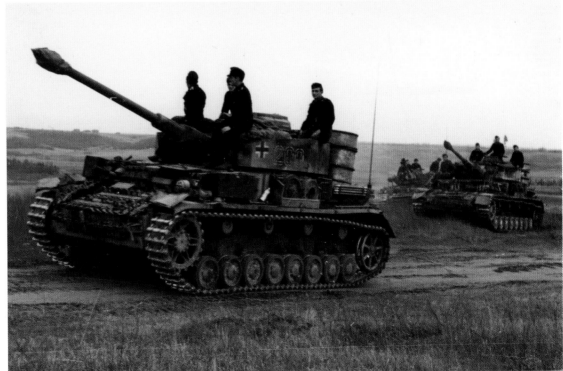

The new-style cast sprocket with the deeply indented spokes is prominent in this view of a Pz. Kpfw. IV Ausf. H preceding several other tanks. The tactical number 200 is stenciled in outline on the turret skirt armor. *National Archives and Records Administration*

Pz.Kpfw. IV Ausf. H, chassis number 86984, with the trident symbol of the 2nd Panzer Division on the right rear of the engine compartment, makes its way through a thicket. This tank, completed by Nibelungenwerk in November 1943, has *Zimmerit* on the turret skirt but not on the hull skirts. Painted in outline on the rear of the turret skirt is the tactical number, 821. Jutting to the front of the crewman on the right is the mount on the cupola for an MG 34. Three spare track links are stored on the left rear of the engine compartment above the muffler for the auxiliary generator motor.
National Archives and Records Administration

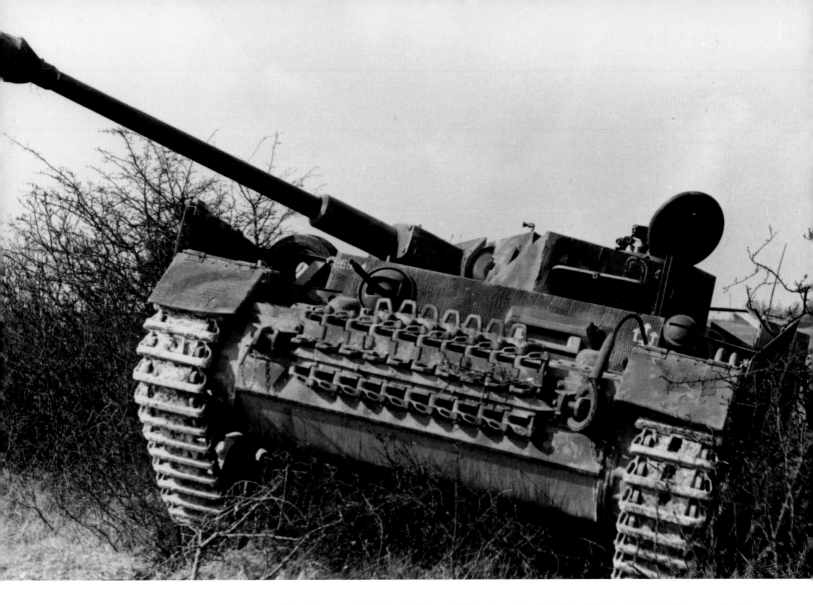

The trident symbol of the 2nd Panzer Division is on the right side of the frontal plate of the same Pz.Kpfw. IV Ausf. H seen in the preceding photo, chassis number 86984. The chassis number is stenciled on the upper right corner of the same plate, but only the first two digits, 86, are visible. A spare road wheel is stashed sideways on the right fender to the rear of the front skirt bracket. *Zimmerit* is present on the vehicle but has not been applied to the bow. *Zimmerit* is visible on the right mudguard but has spalled off the left mudguard. *National Archives and Records Administration*

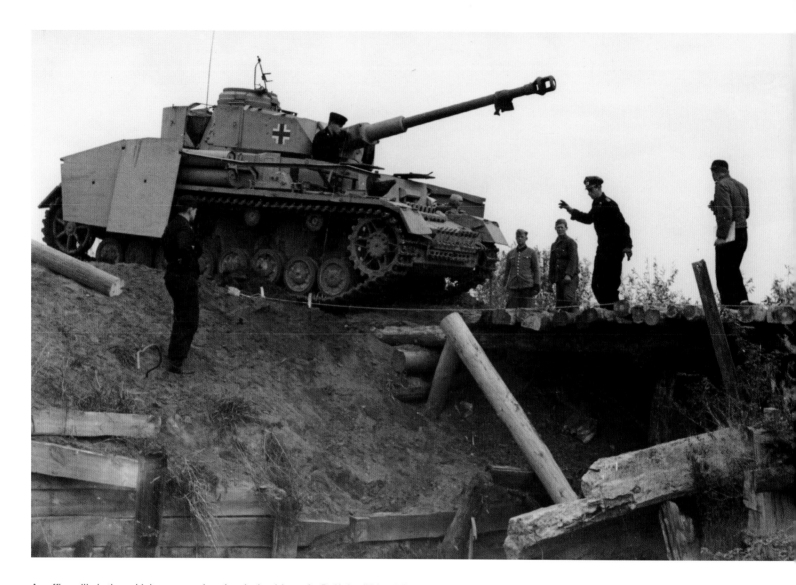

An officer, likely the vehicle commander, signals the driver of a Pz.Kpfw. IV Ausf. H onto a log bridge. The skirts are the early type with cutouts for the hangers. The two cylinders of the felt-bellows air filter on the middle of the right fender are in view. With several of the early-type hull skirts missing, details of the skirt hanger are apparent. It consisted of brackets attached to the superstructure that supported an angle iron with upturned tab-shaped hangers at intervals. One of the tabs is visible at the front of the angle iron. Openings in the skirt plates fit over these tabs, holding the plates in place. This system was rather flimsy, and the skirts were sometimes knocked off their hangers. *National Archives and Records Administration*

The tactical number 621, representing the 1st vehicle of the 2nd Platoon of the 6th Company, is painted on the turret skirt of this Pz.Kpfw. IV Ausf. H. A camouflage pattern of splotches and crossed lines has been sprayed on that skirt. The hull skirts have been removed, revealing the late-type skirt hangers and brackets. This style of hanger was of a large, triangular shape, which did a better job than the early-type hanger tabs in keeping the skirt plates in place. The front end of the angle iron of the skirt hanger has been damaged and is bent downward. *National Archives and Records Administration*

A Pz.Kpfw. IV Ausf. H with the trident symbol of the 2nd Panzer Division precedes another Pz.Kpfw. IV, possibly an Ausf. H, during a road march through a European village. The lead vehicle, tactical number 832, has an application of *Zimmerit* and is equipped with the late-type skirts and hangers. The chassis number, 89272, is stenciled in white on the upper right corner of the front of the superstructure. Nibelungenwerk completed this tank in January 1944. On the right side of the ventilator on the turret roof is a round opening for a *Nahverteidigungswaffe* close-support weapon, a feature on these tanks beginning in January 1944. In December 1943, the hull at the bow was changed, with the side armor extending slightly to the front of, and interlocking with, the 80 mm frontal plate of the bow. The fronts of the extensions of the side plates are visible from this angle.
National Archives and Records Administration

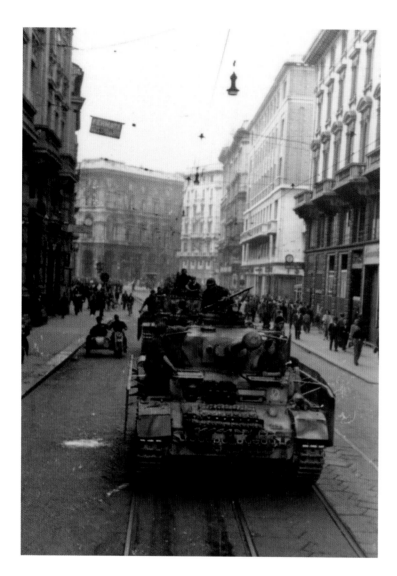

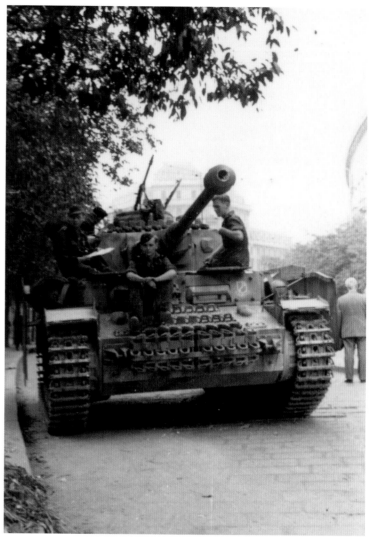

A Pz.Kpfw. IV Ausf. H followed by several other vehicles is halted on a street in Milan, Italy. The vehicles were attached to 1st SS Panzer-Grenadier Division "Liebstandarte SS Adolf Hitler." On the frontal plate of the superstructure in front of the driver is the insignia of the "Liebstandarte Adolf Hitler." The skirt hangers are the early type, with hooks on both the brackets and also the fenders that correspond with holes in the skirts. An MG 34 is on the cupola mount. *National Archives and Records Administration*

Members of the "Liebstandarte SS Adolf Hitler" relax on their Pz.Kpfw. IV Ausf. H. This model of the Pz.Kpfw. IV was armed with the 7.5 cm KwK 40 L/48. This gun had been fitted in Pz.Kpfw. IV Ausf. Gs beginning in April 1943, and it was the main gun of all of the Ausf. Hs. The muzzle brake is a version of the "acorn" type with oblong front and rear baffles. Bolted to the front of the superstructure is 30 mm supplemental armor.
National Archives and Records Administration

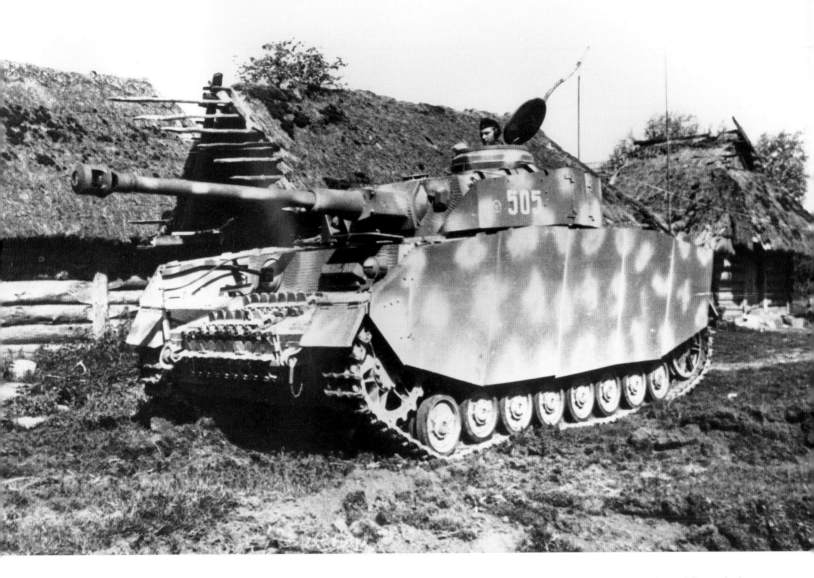

The Y-in-a-circle symbol of the 12th Panzer Division in very small format is to the front of the tactical number on the turret skirt of a Pz.Kpfw. IV Ausf. H in a settlement on the Eastern Front. A camouflage scheme of brown or green has been sprayed atop the *Dunkelgelb* base color. In addition to the stock radio antenna on the left rear of the vehicle, a second antenna is on the right rear. The idler seen here is the new, cast-steel type with deep indentations on the spokes, introduced in October 1943.
Patton Museum

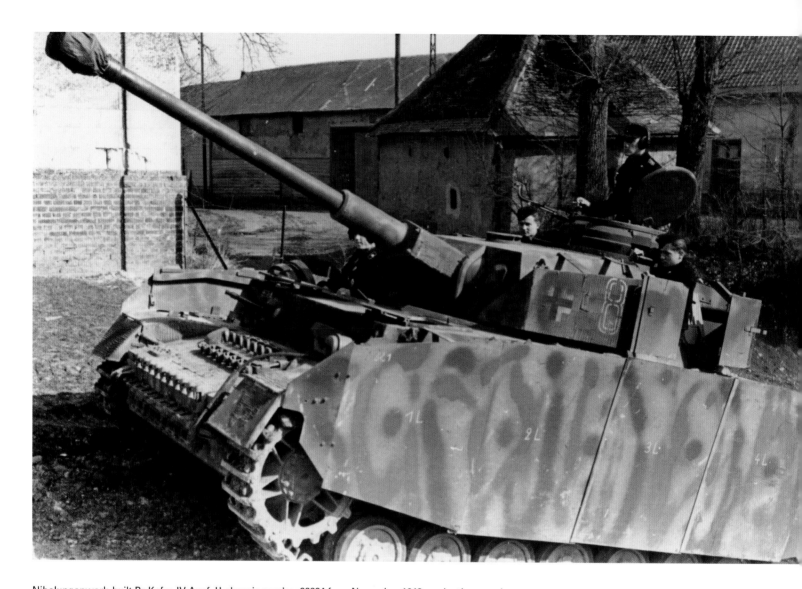

Nibelungenwerk-built Pz.Kpfw. IV Ausf. H chassis number 86984 from November 1943 production, serving with the 2nd Panzer Division, sports a sprayed camouflage pattern of round splotches and irregular curves and lines. Each of the armor skirt panels is numbered from front to rear: 1L, 2L, 3L, et cetera. The letter L presumably stands for *links,* German for "left." The inward-angled front of the skirt has a notch cut out of the front, probably to allow mud on the track to escape. *Zimmerit* is visible on the recoil-mechanism housing to the front of the mantlet, as well as the turret skirt.
National Archives and Records Administration

A group of whitewashed Pz.Kpfw. IVs is halted on a plain during the winter. The nearest vehicle, an Ausf. H, has the tactical number 532 on the turret skirt in thin, black outlining, and a *Balkenkreuz* on the front door of the turret skirt, also in thin, black outlining. This tank has *Zimmerit*, which became standard on the Ausf. H in late September 1943, and it has triangular skirt hangers, introduced the following month. *National Archives and Records Administration*

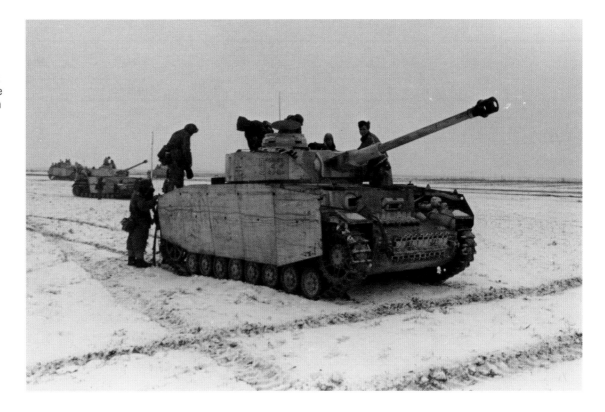

The nearest vehicle in this column of tanks moving along a trail in a forest in Russia around late 1943 is a Pz.Kpfw. IV Ausf. H. On the left rear of the engine compartment is the symbol for the 2nd SS Panzer Division "Das Reich." Originally applied to tanks for Operation Citadel in mid-1943, this symbol, two vertical bars atop a horizontal bar, was retained on the tanks of "Das Reich" well after the Battle of Kursk. *Zimmerit* has been applied to the tank, including the skirt around the turret. Two track-adjustment wrenches, normally stored toward the front of the left fender, are stuck through the guide horns on the spare tracks on the rear of the engine compartment. *National Archives and Records Administration*

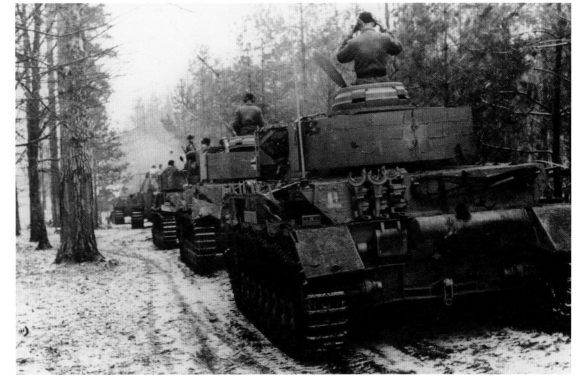

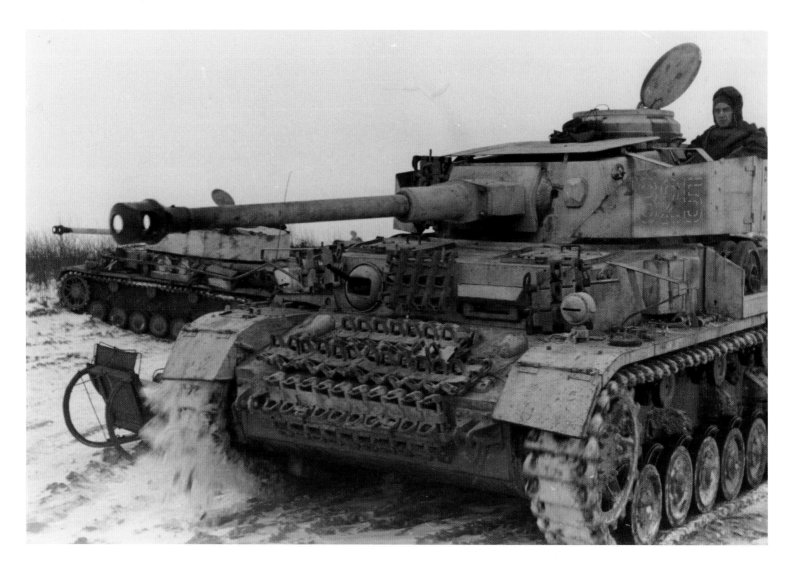

The tactical number 325 is very faintly stenciled on the turret skirt of this Pz.Kpfw. IV Ausf. H. As a modification, a metal plate has been emplaced an inch or two above the forward part of the turret roof, as additional protection. The hull skirt armor and hangers have been removed, but the brackets that hold the hangers remain attached to the superstructure. Sections of spare track have been attached to the front of the superstructure for extra protection. *National Archives and Records Administration*

Approaching the camera is a pair of whitewash-camouflaged Pz. Kpfw. IVs, including a *Zimmerit*-coated Ausf. H in the foreground. This vehicle was completed between October and December 1943, based on the presence of the late-type triangular skirt hangers introduced in October, and the absence of the interlocking bow plates introduced in December. Several of the sections of the late-type armor skirt are missing on the right side, but at least the forward sections of the left skirt are still in place. *National Archives and Records Administration*

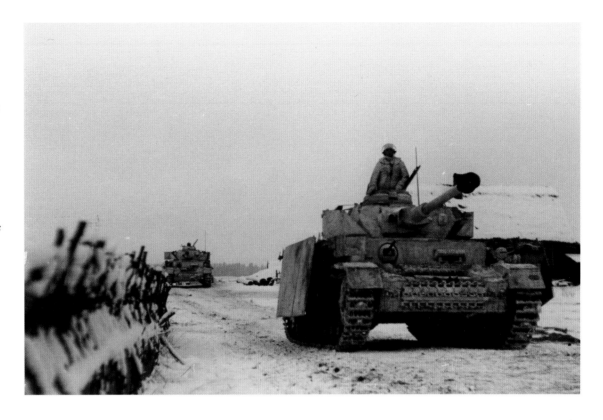

A large chest is stowed between the right skirt and the superstructure of the lead Pz.Kpfw. IV, an Ausf. H, in a procession of tanks. This vehicle has *Zimmerit* and a heavily weathered coating of whitewash. That is not a dark-colored dust cover over the ball machine-gun mount: rather, the mount has an application of dark paint. The face and the parka hood of the vehicle commander is visible above the top of the cupola. *Patton Museum*

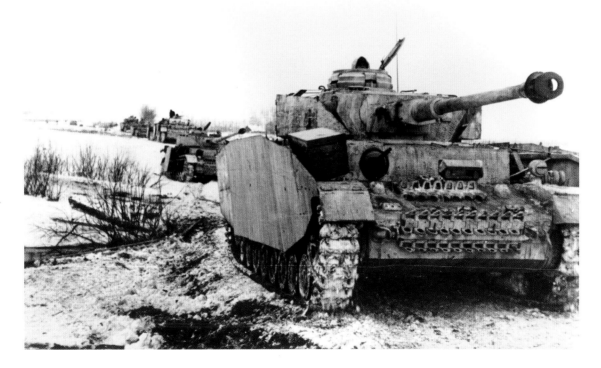

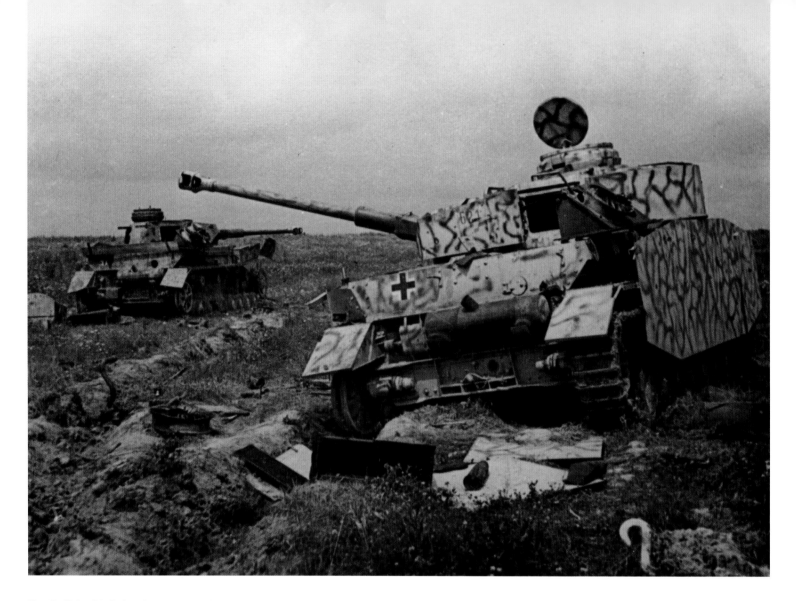

Two Pz.Kpfw. IVs lie in ruins on a battlefield. The vehicle to the right, an Ausf. H or possibly a late Ausf. G, bears a small tactical number, 621, on the turret skirting. On the right side of the engine deck, the hatch is open, showing the ventilator-fan assembly attached to the inside of the hatch. The front fan and its cowling have been blown off. *National Archives and Records Administration*

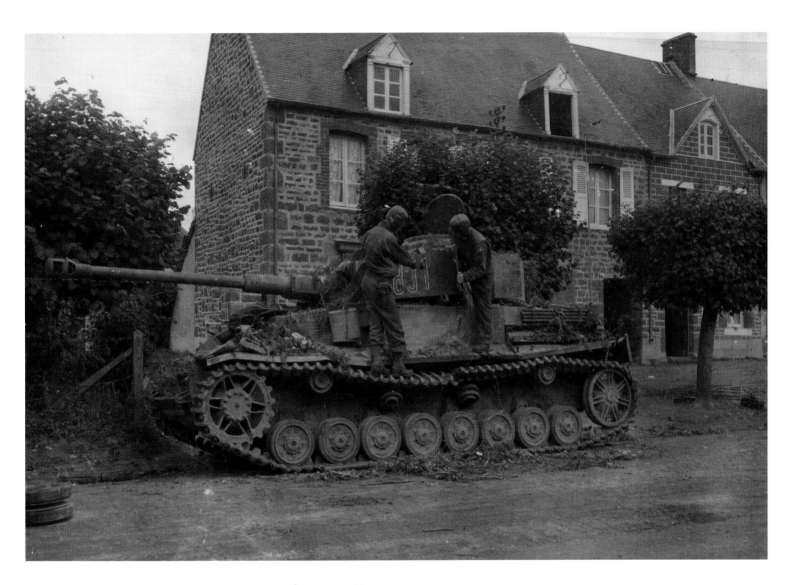

Two US tank crewmen inspect a knocked-out Pz.Kpfw. IV, tactical number 831, on a street in St.-Denis, France, on July 31, 1944. This vehicle has features dating its completion to between December 1943 and April 1944, and it is not clear if it is an Ausf. H or an early Ausf. J. The G.I. on the left is pointing to a hole in the turret skirt armor where a 37 mm projectile pierced it. The two middle track-support rollers have collapsed. *Zimmerit* is present on the side of the superstructure only as far back as the jack block to the side of the driver's compartment. The extended fronts of the side plates of the hull, to accommodate the interlocking frontal plate of the bow, are visible. *National Archives and Records Administration*

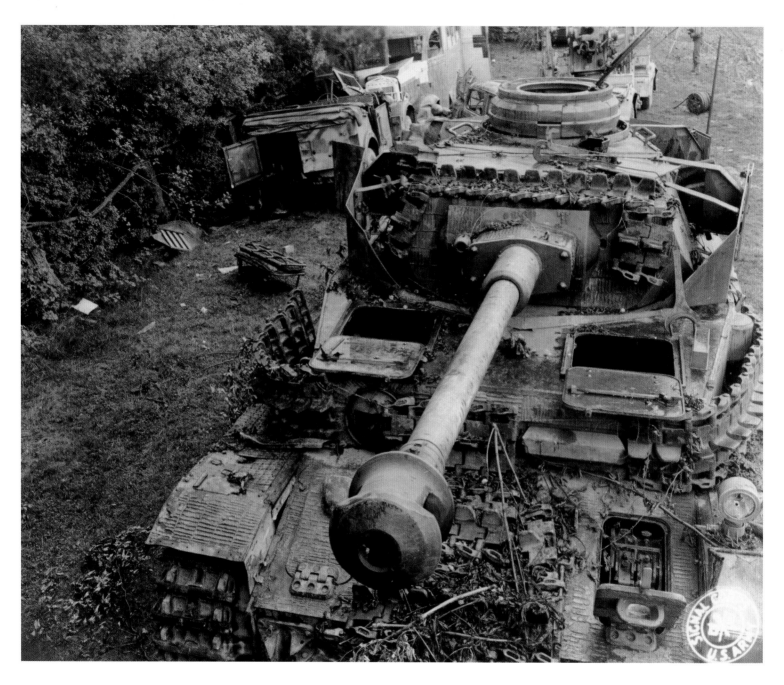

Among the destroyed vehicles along a road apparently during the German retreat from Normandy is a Pz.Kpfw. IV, either a late Ausf. H or an early Ausf. J. A close-up view is available of the 7.5 cm muzzle brake with the elongated face. The access door on the left side of the glacis is open, offering a glimpse of the left steering brake. Sections of spare track are attached with wire to protect the front of the superstructure, with gaps for the driver's visor and the bow machine gun. More track links and sections are on the front of the turret and the front of the turret roof.
National Archives and Records Administration

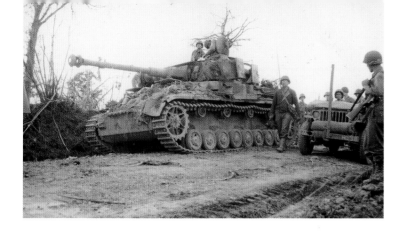

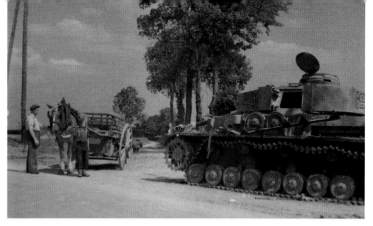

American troops check over a Pz.Kpfw. IV Ausf. H abandoned along a road. Remnants of *Zimmerit* are on the left mudguard. The steel track-support rollers and the cast idlers with deep indentations in the spokes dated from October 1943. The muzzle brake on the 7.5 cm gun is the late type, with a round front. A single link of track is attached to the left front of the turret below the observation port. The tactical number 841 is painted on the turret skirting to the front of the entry door.
National Archives and Records Administration

A farmer and a boy pause to view a knocked-out Pz.Kpfw. IV situated in the middle of a road. The vehicle has the style of cast-steel sprocket with deep grooves in the spokes that was introduced with the Ausf. H. The support for the hull skirts with the late-type triangular hangers is broken and twisted. The left track evidently had become severed and the crew (or the vehicle's captors?) had reconnected it, bypassing the sprocket, in order to allow the vehicle to be towed away. *Library and Archives of Canada*

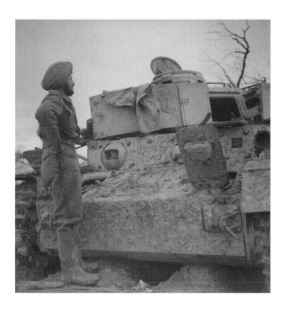

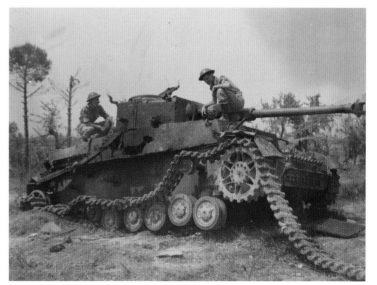

An Indian soldier examines a knocked-out Pz.Kpfw. IV, an early Ausf. H that was produced in May or June 1943. Much of the visible portion of the vehicle is covered with what appears to be a very crude and heavy application of *Zimmerit*, which probably was applied in the field to vehicles which left the factory without *Zimmerit* before late September 1943. Some of the *Zimmerit* has spalled off the turret skirt and the right side of the front of the superstructure.
Library and Archives of Canada

British or Commonwealth soldiers inspect a destroyed Pz.Kpfw. IV Ausf. H. The vehicle has the type of sprocket introduced with the Ausf. H and the older-type idler fabricated from steel tubing. Only one of the track-support rollers and its support remain in place; the second roller and its support were blown off the vehicle, and only the supports of the third and fourth rollers remain in place. The turret skirting was torn off to the rear of the front door, and large holes are in the sponson, the turret skirting, and the hull between and above the third and fourth track-support roller supports.
Library and Archives of Canada

CHAPTER 9
Panzer IV Ausf. J

Ausf. J, 10.series B.W.	
Make	Vomag
Chassis (Fgst) number	86394-86573
Make	Nibelungenwerk
Chassis (Fgst) number	89531-90600 91300-93250 110001-110272
Quantity	about 3,400

Dimensions	
Length	23' .377"
Width	9' 5.39"
Height	8' 9.51"
Wheelbase	8' .85"
Track contact	11' 6.58"
Weight	55,125 pounds
Automotive	
Engine	Maybach HL120TRM
Configuration	V-12, water-cooled
Displacement	11.9 liters
Power output	265 hp @ 2600 rpm
Fuel capacity	124 gallons
Transmission	ZF S.S.G.76
Speeds	6 + reverse
Steering	differential
Track	Kgs 61/400/120
Links per side	99
Performance	
Crew	5
Max speed	23.6 mph
Cruising speed	15.5 mph
Cross-country	12.5 mph
Range, on-road	130 miles
Range, cross-country	80 miles
Fording depth	31.5"
Trench crossing	7.5'
Armament	
Main gun	7.5 cm Kw.K. 40 L/43
Range, direct fire	1,800 meters
Coaxial	7.92 mm MG 34
Elevation	-10 to +20 degrees
Ball mount	7.92 mm MG 34
Ammo, 7.5 cm	87 rounds
Ammo, 7.92 mm	3,150 rounds

The final production model of the Panzer IV was the Ausf. J. The Ausf. J was in many ways a simplified version of the Ausf. H. The electric turret traverse, with associated auxiliary generator, which had been a part of the Panzer IV design from the beginning, was discontinued. Instead, a two-speed manual traverse system was utilized.

It was intended that the space gained in the rear hull by elimination of this generator would be used to mount an additional 53-gallon fuel tank, although one must wonder, given the ever-increasing fuel shortages in Germany, how useful this would be. As it happened, when Ausf. J production began, the new fuel tanks were not available, hence the area remained empty until July 1944, when at last the tanks began to arrive. Installation of these tanks began with chassis number 91501, but it was soon found that the tanks leaked. The lines to the tanks were plugged, and their use discontinued until September, when new tanks arrived that did not leak.

Because of the ongoing Allied bombing campaign, other design changes were made. In June 1944, the requirement that the armor be face-hardened was dropped, a result of damage to the Krupp mills in Essen. In October 1944, roller bearings were removed from the track return rollers. In December, the number of return rollers per side was reduced from four to three, completing an initiative that had begun six months earlier as an effort to save 2,000 roller bearing sets annually.

In July 1944, the decision was made to increase the thickness of the superstructure roof to 16 mm.

In August 1944, a flame-arresting muffler (*flammenvernichter*) was introduced, improving concealment at night. Functionality was further improved in September 1944, when the Schürzen began to be made of mesh, rather than plate; these were known as *Drahtgeflecht Schürzen* or "Thoma shields." This reduced weight and also the build-up of dust on the running gear. On top of the turret sockets (*pilzen*) for mounting a maintenance jib had been installed beginning in June 1944, the same month that the two C-tow hooks previously used for towing were replaced by a single S-hook.

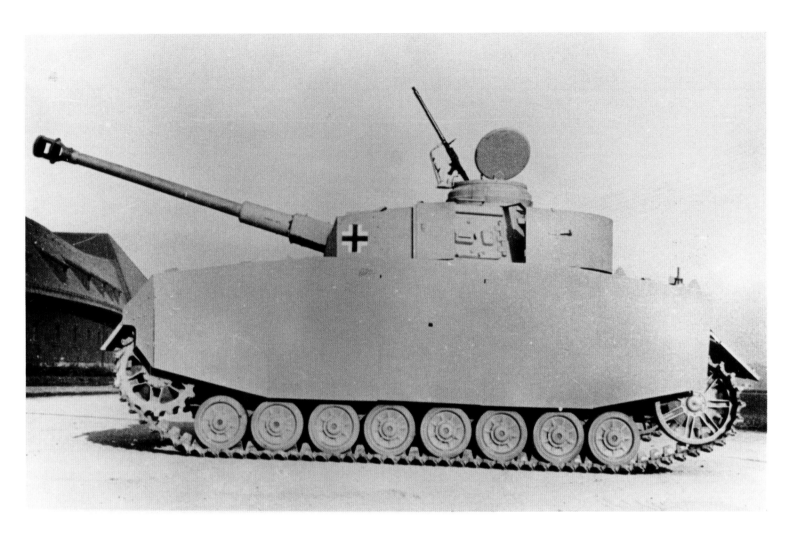

Despite these changes, Germany intended to phase out the Panzer IV in favor of the Panther. Also, increasing numbers of Panzer IV Ausf. J chassis were diverted for production of Sturmpanzer, Jagdpanzer IV, and Flakpanzer IV. Vomag ceased production of the Panzer IV in May 1944, leaving only Steyr's Nibelungenwerk in St. Valentine, Austria (Krupp having exited during Ausf. H production) producing the Panzer IV Ausf. J. Up until Germany surrendered in May 1945, Panzer IV Ausf. Js were still rolling off the assembly line, for a total production of the final model in the 3,400 range (exact figures being unknown, owing to wartime conditions).

The Ausf. J was the final model of the Pz.Kpfw. IV, with 3,150 produced from February 1944 to April 1945. The main difference compared to the Ausf. H was that the Ausf. J eliminated the auxiliary generator for powering the turret, resulting in the deletion of the muffler for the generator motor on the left rear of the engine compartment. In place of the generator, a 200-liter fuel tank was installed in the rear of the engine compartment. The example in this photo was completed at Nibelungenwerke in August or September 1944. *Patton Museum*

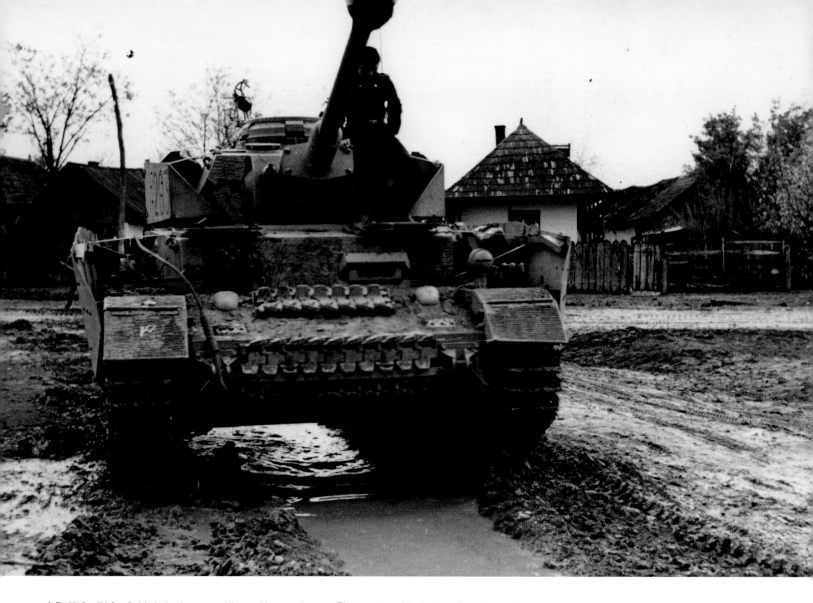

A Pz.Kpfw. IV Ausf. J is halted on a muddy road in a settlement. The turret roof lacks the *pilzen* fittings for a two-ton auxiliary crane, a feature on the Ausf. J from July 1944 on. The spare tracks stored on the bow are mostly the type with the solid guide horn, although there are a few links with the earlier, perforated guide horn. A tow cable is pinned to the tow fitting on the right side of the bow.
National Archives and Records Administration

During the period between late fall of 1944 and early spring of 1945, judging from the lack of foliage on the trees, a Pz.Kpfw. IV Ausf. J takes position in a thicket near a building. On the right rear of the vehicle is the early-type cylindrical muffler; this muffler was replaced by two exhausts with flame suppressors beginning around August 1944. Only the front panel of the armor skirt remains in place on the left side of the tank. *Patton Museum*

Two Pz.Kpfw. IVs exhibit tiger-stripe camouflage patterns. The one in the foreground is an early-production Ausf. J, chassis number 89589, completed in February 1944. This tank had an application of *Zimmerit* and was equipped with the late-style skirts with triangular hangers and the early-type cylindrical muffler. *National Archives and Records Administration*

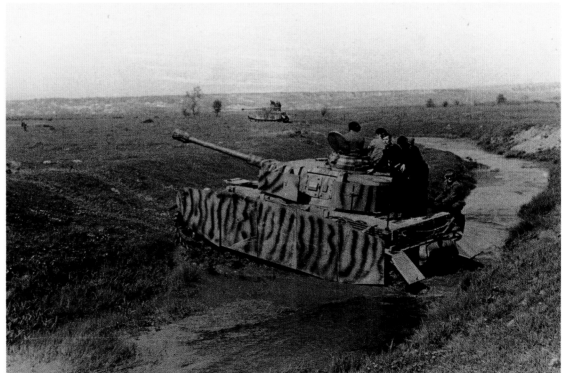

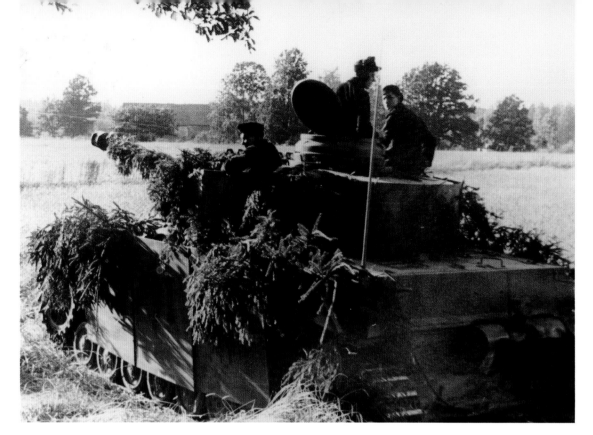

The crew of this Pz.Kpfw. IV Ausf. J on the Eastern Front in 1944 have applied local camouflage—evergreen boughs—to break up the contours of the vehicle and confound enemy gunners as they tried to calculate the tank's identity, range, and bearing. The auxiliary-generator muffler found on previous marks of the Pz.Kpfw. IV is missing, and the cylindrical main muffler installed on the Ausf. J until late 1944, is present. The grab handle on the right access door on the engine deck was a feature particular to the Ausf. J. *National Archives and Records Administration*

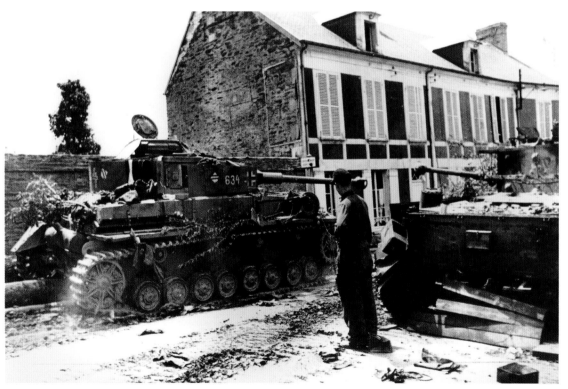

A German soldier surveys an abandoned Pz.Kpfw. IV Ausf. J, tactical number 634, from the Panzer-Lehr Division's Panzer Regiment 130, in a town on the Western Front in 1944. This is an early-production Ausf. J, with four track-return rollers and the cylindrical muffler. The hull skirting has been removed or destroyed, with only a short section of the skirt support, with two triangular hangers, remaining adjacent to the radio-operator's compartment. Small square symbols with two red lines, the family coat of arms of Major Prince von Schönburg-Waldenburg, commander of Panzer Regiment 130's 2nd battalion, are on the side and rear of the turret skirting. *Patton Museum*

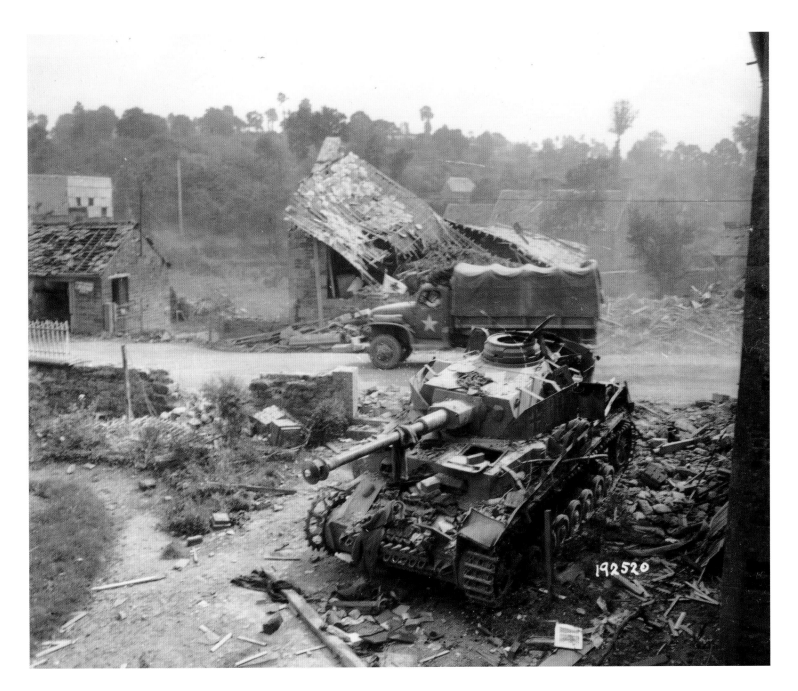

A US Army cargo truck rolls past a knocked-out Pz.Kpfw. IV Ausf. J at Pont-Farcy, in the Calvados Department of Normandy, on August 5, 1944. Bricks and debris from the adjacent building litter the glacis, fenders, and superstructure. On the storage rack for the two road wheel assemblies on the left fender, a metal retainer rod runs between the paired wheels. On the turret roof to the right side of the ventilator is a circular plate, covering the hole for the *Nahverteidigungswaffe* close-support weapon.
National Archives and Records Administration

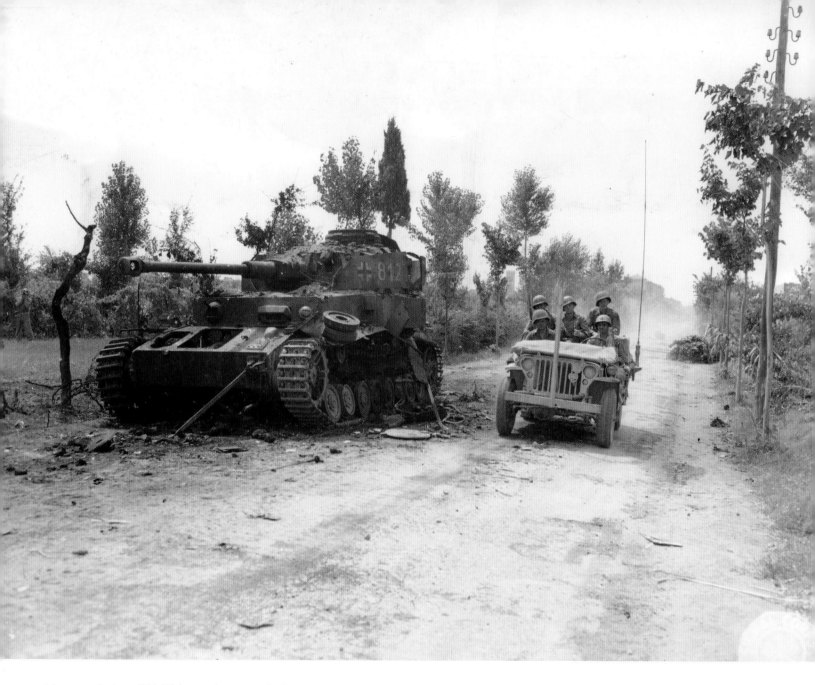

A jeep attached to a Fifth US Army unit passes a Pz.Kpfw. IV Ausf. J knocked out by a direct hit by an artillery shell in the Pontedera area of Italy on July 18, 1944. The tactical number 812 and a black and white *Balkenkreuz* are on the turret skirting. Both of the fenders and the mudguards are torn apart, and two of the three access hatches on the glacis have been blown off. What appears to be a tow bar is attached to the left tow fitting on the bow. *National Archives and Records Administration*

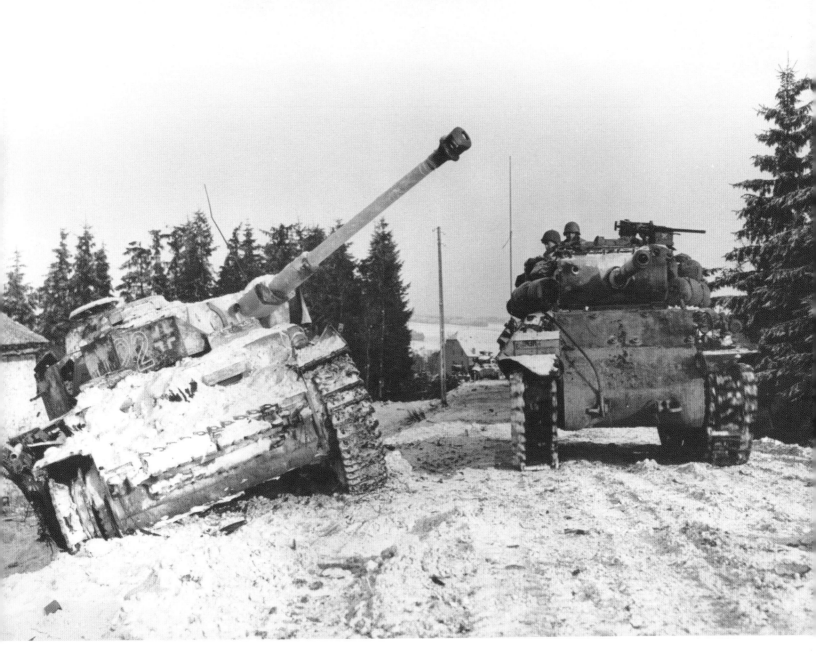

A US Army M36 of the 703rd Tank Destroyer Battalion, 3rd Armored Division, passes a knocked-out Pz.Kpfw. IV outside of Lonlir, Belgium, on January 13, 1945. The remnants of whitewash camouflage are evident on the snow-covered German tank. On the right side of the tank is wire-mesh skirting mounted on a tubular support. This type of mesh skirting made its debut on the Pz.Kpfw. IV in September 1944 and was a lighter-weight alternative to armor plate skirts. *National Archives and Records Administration*

A Canadian armored crewman poses on the front of a knocked-out Pz.Kpfw. IV Ausf. J. All but the front and the rear track-support idlers on the right side are missing. The tracks have the chevron-type cleats for better performance on ice. The outboard side of the left tow fitting on the bow is missing, leaving a light-colored patch with three bolt holes where it normally was situated. The muzzle brake on the 7.5 cm gun is a late type (but not the final type) with a round front baffle and a larger, round rear baffle, which was installed in the summer and fall of 1944. *Library and Archives of Canada*

American soldiers are checking over a captured Pz.Kpfw. IV Ausf. J, tactical number 841, in France around late July or early August 1944. This vehicle has attributes of one completed between February and June 1944, as the 7.5 cm gun has the late-type muzzle brake with a large, round front baffle, introduced to production in June 1944. This tank also has Zimmerit, cast idlers, and all-steel track-support rollers. *National Archives and Records Administration*

A Sherman tank passes several abandoned Pz.Kpfw. IVs from 2nd SS Panzer Division "Das Reich." Both of the Panzer IVs lack auxiliary-generator mufflers, an indication they are Ausf. Js. The cylindrical muffler visible on the closer Pz.Kpfw. IV is the type installed at the factories until July 1944. The track-support rollers are all steel; cast-steel idlers are employed. Most of the skirt panels on the left side are missing, and the remaining one is shot-up. The radio antenna is mounted on the left rear of the engine compartment. *National Archives and Records Administration*

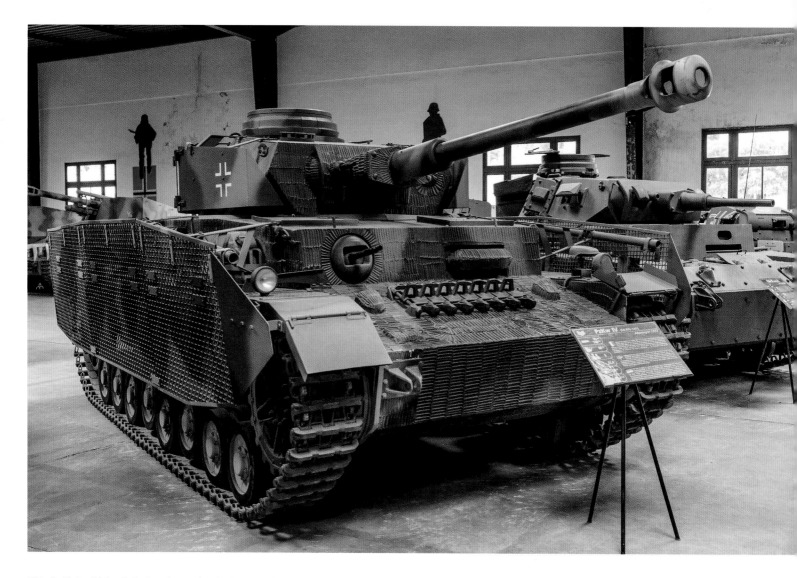

This Pz.Kpfw. IV Ausf. J, chassis number 89660, completed by Nibelungenwerke in March 1944, had been almost destroyed when it was rescued from the Etablissement Technique de Bourges firing ranges, with large sections missing from the hull and turret. Since being restored, it has been preserved at the Musée des Blindés, Saumur, France. *Massimo Foti*

The turret skirt on the restored Pz.Kpfw. IV Ausf. J at Saumur, as viewed from the rear, is a recent reproduction that has been criticized for being of incorrect shape and detailing. Below the skirt is the access door for the radiator filler in the engine compartment. The door has a lock on the left side, hinges on the right, and rests on a raised pyramidal structure. *Massimo Foti*

The radiator-filler door is viewed from a perspective more to the right on the engine deck of the Pz.Kpfw. IV Ausf. J at Saumur. Also in view in the foreground are a hinge for one of the engine-access doors and two rectangular plates, secured with flush-mounted slotted screws, containing the locking mechanisms for the access doors. *Massimo Foti*

The access panel on the right side of the engine deck is viewed from the rear. A ventilation grille and a grab handle are attached to the panel. To the right is an approximated replica of the wire-mesh skirting that was introduced beginning with Pz.Kpfw. IV Ausf. J chassis number 92301 in September 1944. *Massimo Foti*

The restored Pz.Kpfw. IV at Saumur is viewed from the left rear. The *Zimmerit* reportedly was added during the restoration process, and is inappropriate for a vehicle with wire-mesh skirting. The idlers are the cast-steel type with deep indentations on the spokes. The muffler is the correct style for a Pz.Kpfw. IV Ausf. J through late summer 1944, after which the twin flame-suppressor exhausts were used. *Massimo Foti*

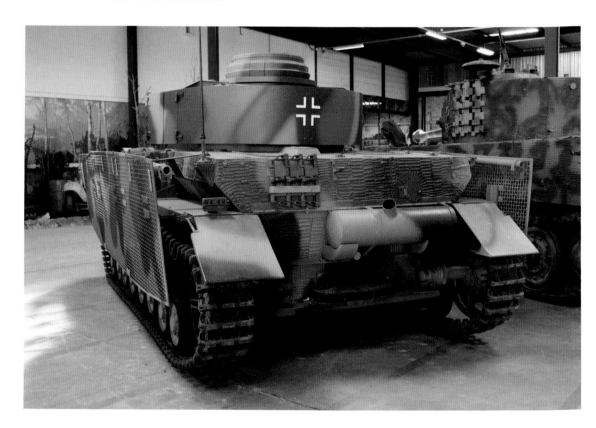

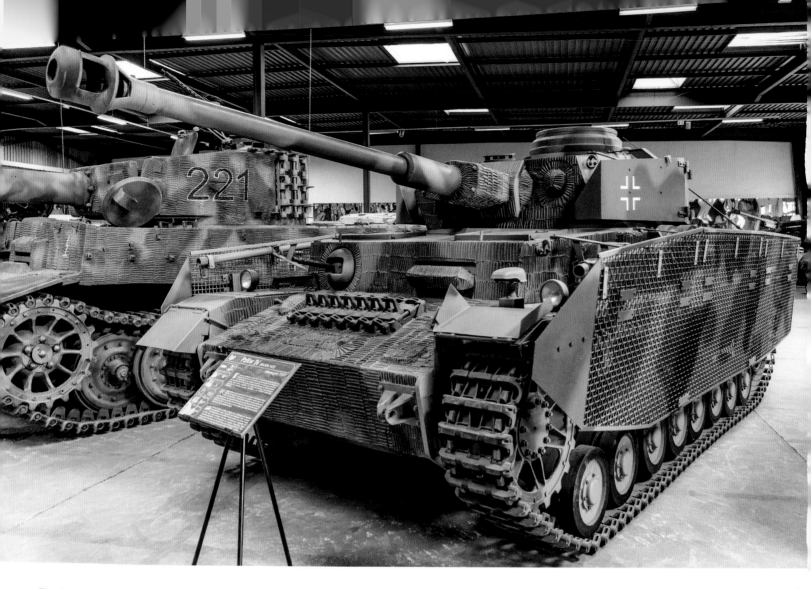

The Pz.Kpfw. IV Ausf. J at Saumur has a beautiful replica of a *Zimmerit* application, but it is arguably a more meticulous application than would have been the norm for wartime factory applications. The hubcaps on the bogie wheels on the vehicle are not accurate reproductions of a Pz.Kpfw. IV hubcap, although the wheels themselves may be authentic. *Massimo Foti*